IMAGES
of America

CABELL COUNTY

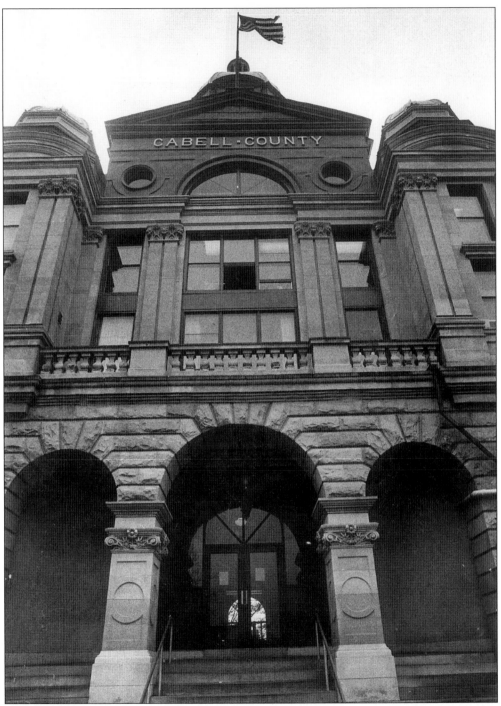

Completed and occupied in 1901, the Cabell County Courthouse surely is the most visible symbol of the county. This is where judges and juries dispense justice, where the milestones of life—births and deaths, marriages and divorces, the buying and selling of property—are recorded, and where, on election night, the votes are tallied. In one way or another, the life of every county resident is touched by what goes on within these walls.

IMAGES
of America

CABELL COUNTY

James E. Casto

ARCADIA

Published by Arcadia Publishing,
an imprint of Tempus Publishing, Inc.
2 Cumberland Street
Charleston, SC 29401

Printed in Great Britain.

Library of Congress Catalog Card Number: 2001093342

For all general information contact Arcadia Publishing at:
Telephone 843-853-2070
Fax 843-853-0044
E-Mail sales@arcadiapublishing.com

For customer service and orders:
Toll-Free 1-888-313-2665

Visit us on the internet at http://www.arcadiapublishing.com

CONTENTS

ACKNOWLEDGMENTS

I love old photographs. And I bet you do, too. As a newspaperman, it's been my good fortune over the years to not only encounter a great many old photographs but also have an opportunity to talk with some of those who can unlock their secrets. Much of what I have learned I now pass on to you in this volume.

This is by no means an encyclopedic history of Cabell County. Such an ambitious task would require a book much larger than this and hands far more capable than mine. Instead, in assembling this collection I've come to think of it as a scrapbook that offers some intriguing glimpses into our local history—scenes such as that on our cover, showing D.E. Abbott & Company employees at a company outing.

The photographs herein have been gathered from a number of sources, including my own collection and the files of *The Herald-Dispatch*. Those in the "River and Rail" chapter come mostly from the files of steamboat expert G.W. "Jerry" Sutphin and amateur rail historian Bob Withers. I am in their debt. And I owe a huge vote of thanks, too, to all those who in the past have chronicled Cabell County's story, especially George Selden Wallace, whose *Cabell County Annals and Families* remains *the* book on local history. A work such as this depends greatly on the work of others, such as Wallace, who have gone before.

I appreciate the many who have aided me in this endeavor—too many to name. If you helped, you know who you are. And you know, too, that I'm grateful.

INTRODUCTION

Which white man first saw Cabell County is not known. It may well have been a French fur trader, Rene-Robert Cavelier, Sieur de La Salle. In 1669, while exploring the unmapped wilderness south of the Great Lakes, La Salle came upon the Ohio River and descended it as far as the falls just outside the present city of Louisville, Kentucky. That means he and the other men in his party would have paddled their canoes past the wooded shore that would become Cabell County.

In 1749, the French sent a military expedition down the Ohio "to establish tranquility among some villages of savages in these parts." At various spots along the riverbank, the expedition buried metal plates claiming the river and all the land around it as French territory.

Those metal plates notwithstanding, the British insisted that the river and all the land along it belonged to them. It was perhaps inevitable that the French and British would take up arms to enforce their rival claims, and they did so in what has become known as the French and Indian War. This North American clash was but a sideshow to the massive European conflict between the two nations, the Seven Years' War. When the Treaty of Paris was signed in 1762 ending the war, it guaranteed that the British flag, not the French, would fly over the Ohio Valley.

In 1772, the Virginia colonial government made a grant of more than 28,000 acres of land at the confluence of the Ohio and Big Sandy Rivers to John Savage and 60 other men in recognition of their military service in the French and Indian War. This is generally referred to as "the Savage Grant" and is what attracted the first settlers to the county.

The county's early population was sparse and mostly confined to the banks of the Ohio, Guyandotte, and Mud Rivers. The Virginia General Assembly granted official charters to Guyandotte in 1810 and Barboursville in 1813. By the 1830s, Guyandotte had become a busy stagecoach stop and it would become an important steamboat landing.

The turmoil of the Civil War, which in 1863 spawned the new state of West Virginia, took a heavy toll on Guyandotte, where allegiances were sharply divided, with some families supporting the Union and others rallying to the Confederate cause. Union forces garrisoned Guyandotte and in November 1861, in retaliation for a Confederate raid, burned much of the town.

The end of the Civil War saw a restored Guyandotte resume its role as the commercial center of the county. The village was especially important as center for the timber trade. Trees would be felled and then floated down the Guyandotte River to the village, where they were sorted

and made ready for the sawmill. Those not sent to Guyandotte's own mill were lashed into crude rafts and floated down the Ohio to market.

This, then, was the Cabell County that railway mogul Collis P. Huntington found when he arrived on the scene.

A Connecticut native who started his business life as a Yankee peddler, Huntington made a fortune in the California gold rush of 1849, not by mining for gold but by selling supplies to the miners. Later, he joined forces with three other California businessmen—Charles Crocker, Mark Hopkins, and Leland Stanford—to build the Central Pacific, the western link in the long-dreamed-of transcontinental railroad. When Huntington bought a controlling interest in the Chesapeake & Ohio Railway Company in 1869, many scoffed at his purchase. And little wonder. The C&O was not much more than a few miles of Virginia track and a rag-tag collection of rolling stock. However, the canny Huntington knew that if tracks could be laid across the then-new state of West Virginia to the Ohio River, then the C&O could connect there with the Ohio's steamboats and open up an important (and profitable) new artery of commerce.

Huntington, traveling in person to the banks of the Ohio, rejected the overtures of several small communities eager to welcome the railroad. Instead, he picked out a stretch of farmland on the Ohio just downstream from the mouth of the Guyandotte and there commenced the building of a new town.

Local legend has it that Huntington's decision was based as much on personal pique as on business considerations. As the story goes, Huntington and the other men who were traveling with him arrived in Guyandotte and went into a boarding house, leaving their horses hitched outside. While Huntington was inside, his horse somehow turned around and, instead of standing on the street side of the hitching rack, was standing on the steps of the boarding house, blocking the way for anyone going in or out. As it happened, the mayor came along and saw what happened. Entering the boardinghouse, he angrily demanded to know who owned the offending horse. When Huntington said it was he, the mayor fined him. The next day the citizens of Guyandotte were sorely disappointed to learn that their village was not going to be the new western terminus of the C&O.

It's a nice little story. Unfortunately, there's zero historical evidence to support it. More likely it was Huntington's intention all along to build his own town because doing so enabled him to make a tidy profit on the sale of building lots to the businesses and new residents that flocked to his new town.

Huntington placed Delos W. Emmons, his brother-in-law, in charge of procuring the necessary land for the new town and Emmons purchased 21 farms, totaling roughly 5,000 acres. The purchase price, alas, is lost in the mists of history. Much of the property was reserved for the railroad: for right of way, repair shops, a passenger depot, freight sheds, and other necessary buildings. The remaining land was sold off in lots. At Huntington's direction, Boston civil engineer Rufus Cook designed a town plan with a perfect geometric gridwork of broad avenues and intersecting streets, all consecutively numbered so that any address would be easy to find.

From the very outset, the city of Huntington grew and prospered as a gateway to and from the coalfields of southern West Virginia, with coal flowing to market via the new town and manufactured goods flowing the other direction, a two-way traffic that spawned thousands of jobs. The city also attracted a wide variety of manufacturers.

Huntington became the county seat of Cabell County and today is the center of a Tri-State area that includes the Cabell County communities of Barboursville and Milton and the adjacent Wayne County communities of Kenova, Ceredo, and Wayne. Many who work in Huntington live in those smaller communities or in their counterparts in neighboring Ohio and Kentucky.

One
OUR STORY BEGINS

In pre-Revolutionary America, the colonial government in Virginia frequently redrew the colony's county lines, thus in the years from 1619 to 1789, the territory that we now know as Cabell County was successively part of a half dozen counties west of the Blue Ridge Mountains. In 1789, Kanawha County was formed from parts of Augusta and Montgomery Counties and its western boundary was fixed at the Ohio River. Twenty years later, in 1809, Cabell County was formed from a part of Kanawha County.

Cabell County's present area is 261 square miles, fronting along the Ohio River for a distance of roughly 25 miles. The land is drained by the Ohio, Guyandotte, and Mud Rivers, along with a number of smaller creeks. Except along the riverbanks, the land is hilly and steep. When the first white settlers arrived, it was covered with timber, all of which has been cut. The trees that now stand are almost all second or third growth.

In Cabell County's earliest years, its largest communities were Guyandotte and Barboursville. But all that changed when rail tycoon Collis P. Huntington purchased a mostly vacant tract of river bottom along the Ohio just downstream from Guyandotte and there, in 1871, set about erecting the town that is his namesake.

Cabell County was named in honor of William H. Cabell (1772–1853) who was governor of Virginia from 1805 to 1808. Judge John Coalter, who organized the county, did so after buying a 4,400-acre tract of land along the Ohio from Cabell, who had bought it at a bankruptcy auction at the Eagle Tavern in Richmond, Virginia. Cabell's winning bid: $13,000.

Along with his brothers, William H. and Robert, James Holderby (1782–1855) owned much of the land that today comprises Huntington. He served as sheriff and later as a member of the county court but is best remembered for the river wharf that carried the family name—Holderby's Landing. Located at the foot of what is now Hal Greer Boulevard, the landing was a busy place when the Ohio River was the county's primary artery of commerce.

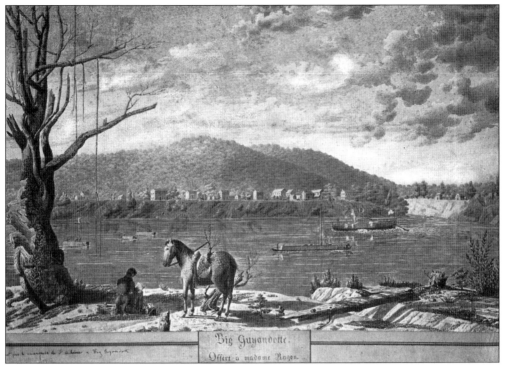

The Virginia General Assembly granted an official charter to the village of Guyandotte in 1810 and by 1835 it boasted 40 dwellings, 5 stores, a church (housing several denominations), and a grist mill. This 1821 watercolor depicts the village as seen from the Ohio shore. Note that the whimsical artist has included himself, sketchpad in hand, in the scene at lower left.

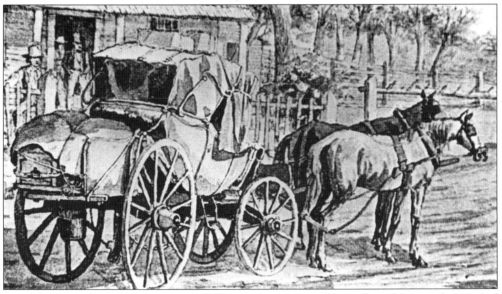

In 1831, Guyandotte became an overnight stop for stagecoaches, such as this one, that carried passengers along the James River and Kanawha River Turnpike, a toll road that stretched west from Covington, Virginia, to the confluence of the Big Sandy and the Ohio, just downstream from what is today Huntington.

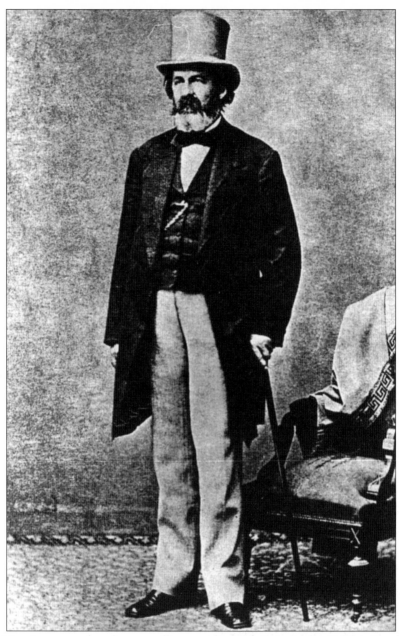

Collis P. Huntington made a fortune selling supplies to miners in the California gold rush of 1849 and then was a key player in construction of the transcontinental railroad. When he bought a controlling interest in the Chesapeake & Ohio Railway in Virginia, he knew its tracks had to be quickly extended westward across the then-new state of West Virginia if the fledgling railroad was to survive. So he personally set out to inspect the proposed right-of-way. Legend has it that he intended to make Guyandotte the C&O's western terminus but changed his mind after he was fined by the mayor for allowing his horse to block the doorway of a boarding house. More likely, canny Huntington intended all along to do exactly what he did—purchase a vacant tract of land and build his own town. Lots in the new town sold briskly, as people flocked to it, and most of the dollars from the land sales ended up in Huntington's pocket.

Born in Guyandotte in 1814, Peter Cline Buffington was a county surveyor and a member of the Virginia General Assembly. In 1871, when the first elections were conducted in Collis P. Huntington's new town, Buffington was elected its first mayor. Buffington, who in his later years sported a beard that reached below his waist, served as mayor until 1874. At the time of his death in 1875, he was a member of Huntington City Council.

The new city of Huntington was only eight years old in 1879 when Edward S. Buffington, the oldest son of Peter Cline Buffington, became its sixth mayor. Born in 1847, E.S. Buffington served in both the Confederate Army and Navy. A physician by profession, "Doc" Buffington, as he was called by one and all, practiced medicine in Huntington for more than 50 years until shortly before his death in 1880.

Few names are written larger in the early history of Cabell County and Huntington than that of John Hunt Oley (1830–1888). A native of Utica and a member of the New York National Guard at the beginning of the Civil War, he was dispatched to West Virginia and raised a regiment that became the 7th West Virginia Cavalry. The unit fought with distinction and Oley rose to the brevet rank of brigadier general. Employed by Collis P. Huntington as treasurer of his Central Land Company, Oley arrived in the new town of Huntington in the year of its birth and was elected recorder, a post he continued to fill until his death. Even though many of Huntington's leading citizens were Southern sympathizers, with some having worn the Confederate gray, Oley was said to be enormously well liked. He was a member of the school board and on his death the community's newly built school was named in his honor.

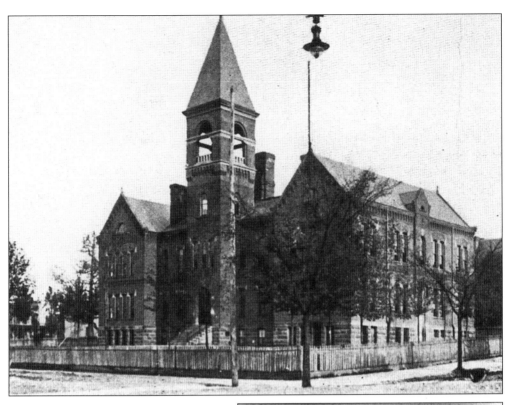

Above, Oley Public School is shown as it looked in the 1890s. Originally, it housed all 12 grades. In 1916, with the construction of Huntington High School, Oley lost its older students and its name was changed to Central School. In the early 1930s, the school's name was changed back to Oley. The school was closed, then demolished, several years ago. Its Fifth Avenue site is now a hospital parking lot.

Arriving in Huntington in 1872, John Hooe Russell initially entered the grocery business, but when the Bank of Huntington, the city's first, was organized, he became its cashier. Three years later, he was named its president following the death of the bank's first president, Peter Cline Buffington. Russell was one of the founders of Trinity Episcopal Church and was a vestryman there for almost 30 years.

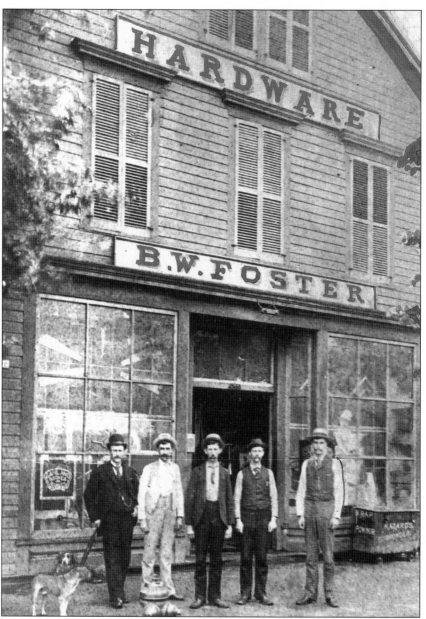

In 1868, Bradley W. Foster (1834–1922) married Mary Lenora Huntington, a niece of Collis P. Huntington, and three years later the couple moved to the embryonic city named after Mary's uncle. On his arrival, Foster opened one of the young city's first hardware stores, shown here, at Third Avenue and Ninth Street. Foster's business boomed as the city grew and he later relocated his store to new quarters at Second Avenue and Twelfth Street. After a 1916 merger, the firm became the Foster-Thornburg Hardware Company and continued to do business under that name until 1965. One of early Huntington's best-known citizens, Foster was one of the original stockholders in the First National Bank, served on city council, helped organize the Huntington Chamber of Commerce (originally housed in his store), was president of the Huntington Land Company (an outgrowth of Collis P. Huntington's original Central Land Company), and established the charitable Foster Foundation.

Entering the Confederate Army at age 17, John Henry Cammack (1843–1920), fought through the entire conflict. Returning home to Clarksburg, he eventually moved to Williamstown in Wood County, where he started a cigar factory. Urged by his doctor to find a healthier pursuit, he moved to Huntington, arriving in 1878. Initially, he established a retail clothing business but in 1890 sold his store and went into real estate and insurance.

Sam Gideon (1836–1923) was born in Germany and came to this country in 1854 without a penny to his name. A family friend took him in. With the coming of the Civil War, Gideon volunteered to fight for the Union. The war over, he moved to Cincinnati, married, and in 1872 arrived in Huntington. "Uncle Sam," as he was known, operated a popular clothing store and was active in local politics.

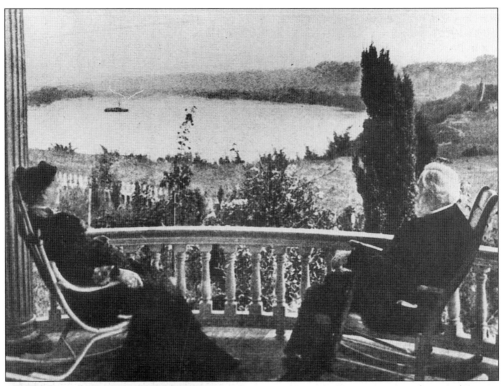

Delos and Mary Emmons relax on the front porch of their home, Pleasant View, overlooking the Ohio River. Located on what is now Staunton Road, the house was surrounded by 15 acres of land, on which stood several large horse and cattle barns and a network of elaborate flower gardens. The Emmons home was a center of social activity in early Huntington.

When Delos W. Emmons (1828–1905) and his wife, Mary, arrived via steamboat at Guyandotte in 1869, he had an important mission to perform for his brother-in-law, Collis P. Huntington. For Huntington had entrusted Emmons with the critical mission of purchasing the land needed for the new western terminus of the Chesapeake & Ohio Railway. Emmons would remain Huntington's trusted right-hand man in the community for more than 30 years.

18

Born in Germany, Adolph Broh (1840–1923) worked as a tailor, first in New York, then in Memphis, Tennessee, where he opened his own shop. He fought with the Confederate Army in the Civil War and was wounded in the knee at Shiloh. After the war, he returned to tailoring, opening a string of shops, including one in Huntington, where in 1887 he put his sons Mike and Julius in charge.

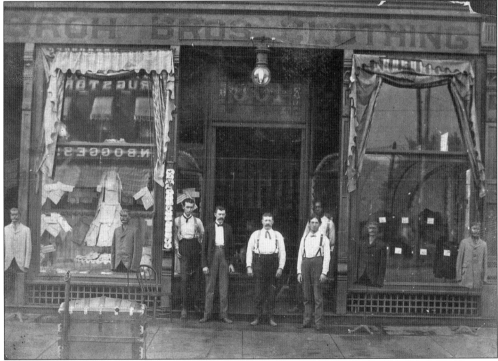

The Broh brothers' business quickly outgrew their original store, so their father built a new three-story building at Third Avenue and Ninth Street. For the next 15 years, the brothers prospered as "dealers in men's clothing, furnishings, and shoes." In 1904, the two dissolved their partnership and divided the business between them. Mike kept the old location, while Julius opened a shoe store elsewhere on Ninth Street.

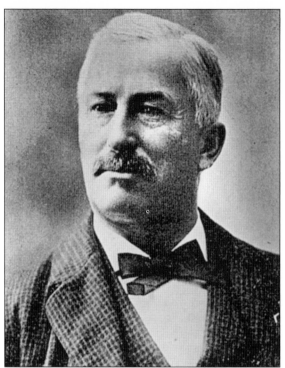

If the Chesapeake & Ohio Railway, with its busy repair shops and other operations, was the new city of Huntington's first industry, its second surely was Ensign Manufacturing Company, chartered in 1872 to produce freight cars, wheels, and other parts for the C&O. Ely Ensign (1840–1902), manager of the plant, was also active in a number of other business ventures and was elected mayor in 1896.

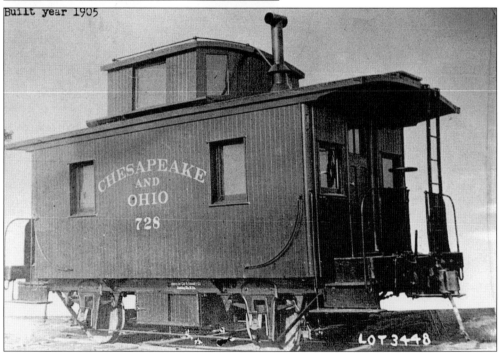

By the mid-1890s, the Ensign plant at Third Avenue and Twenty-third Street was turning out 4,000 rail cars a year, not just for the C&O but for a long list of railroads, both in this country and abroad. In 1899, Ensign became part of the American Car & Foundry Company (now ACF Industries). Typical of the plant's production was this C&O caboose, built in 1905.

Two

RIVER AND RAIL

After the American Revolution, a tide of settlers, many of them veterans of the war with the British, made their way into the sparsely populated Ohio Valley. In the absence of any good roads, the Ohio River was the settlers' highway. These early settlers were a varied lot. Some were men of wealth looking for chances to invest their capital. Many were farmers. Others were blacksmiths, gunsmiths, harnessmakers, or other artisans. Many a future merchant left his home in the East, traveled to Pittsburgh, bought a flatboat (or a share in one) and then headed downstream with a load of goods.

Thus it was, long before the arrival on the scene of Collis P. Huntington, that the Cabell County riverbanks at Guyandotte and Holderby's Landing were busy places. Indeed, it was the Ohio River and its steamboat traffic that lured the rail tycoon and the tracks of his Chesapeake & Ohio Railway to Cabell County.

In 1873, when the first C&O train arrived in the new town of Huntington after traveling across the mountains from Richmond, Virginia, its arrival forever stamped the community as a "railroad town." But the river and the railroad both played important—and colorful—roles in the growth and development of Cabell County.

Some of Cabell County's first settlers floated down the Ohio on flatboats such as this one. Flatboats couldn't fight the current and travel upstream, so they generally were beached and sold for lumber when they arrived at their destination. Before long the flatboats gave way to keelboats. Because they were propelled by men who pushed the boat forward with long poles they thrust into the riverbed, keelboats could travel upstream.

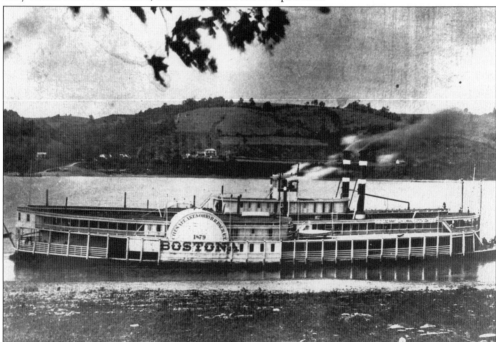

Poling a keelboat upstream was backbreaking work; people knew there had to be an easier way. And there was. The first steamboat appeared on the Ohio in 1811 and by 1835 nearly 700 had been built and placed in service. The steamer *Bostona*, shown here, was typical of her day. She ran regularly in the Huntington-Cincinnati trade from 1879 to 1883, when the C&O extended is tracks from Huntington on to Cincinnati.

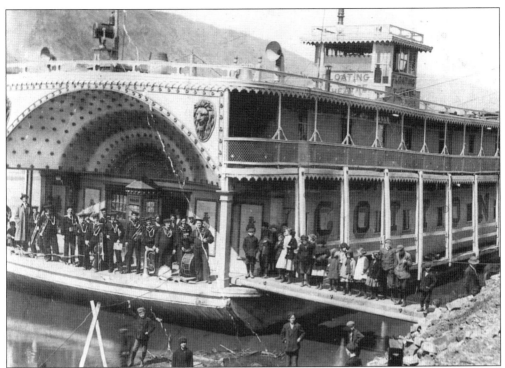

The Ohio River brought not only passengers and freight to Huntington and Cabell County, it also brought entertainment. The *Cotton Blossom* was only one of several showboats that stopped regularly. The typical showboat had no motive power of its own, but instead was pushed from town to town by another vessel.

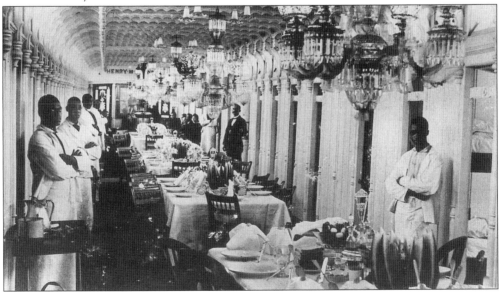

Many of the Ohio River steamers were lavish in their appointments. The fancy tables and attentive staff of the steamer *Henry M. Stanley* are one example. A frequent visitor to the young city of Huntington, the *Stanley* was built at Murraysville, West Virginia, in 1890 and sank near Gallipolis, Ohio, in 1907.

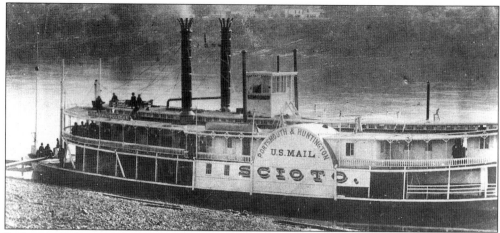

Built in 1875 at Ironton, Ohio, the *Scioto* was sold in 1882 to the Wheeling-Parkersburg Transportation Company. Involved in a collision with the *John Lomas*, she sank about 20 miles above Wheeling. The *Scioto*'s captain was said to have been drinking. She was raised and renamed the *Regular* but was scrapped a short time later.

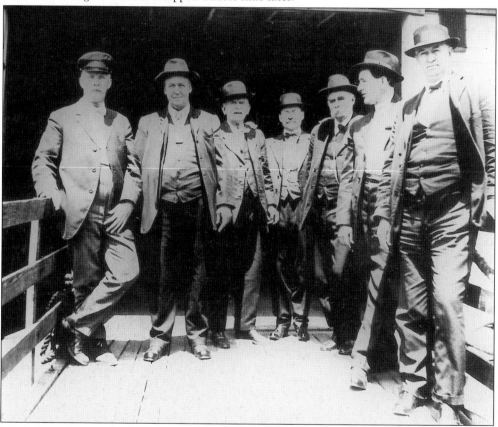

The steamer *Tacoma* had just landed at Huntington when this group of rivermen posed for the camera. All dressed up, they were headed up the riverbank to attend a 1914 revival conducted by famed evangelist Billy Sunday. At far right is Capt. Gordon C. Greene, famed river pilot, boat owner, and founder of Greene Line Steamers Inc. of Cincinnati.

24

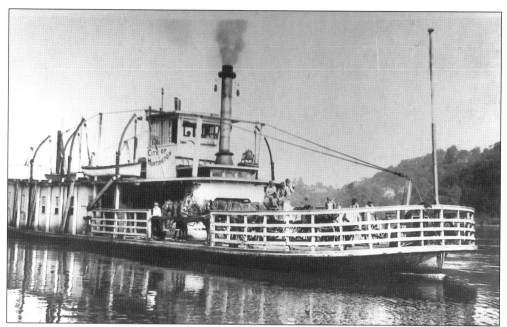

Before the Ohio was spanned by the Sixth Street Bridge, folks who wanted to cross the river at Huntington had to do so by ferryboat. This craft was originally named the *New Pike* when it was built in Madison, Indiana, in 1877. Rebuilt in 1918 and brought to Huntington for use as a ferry, it was renamed the *City of Huntington*.

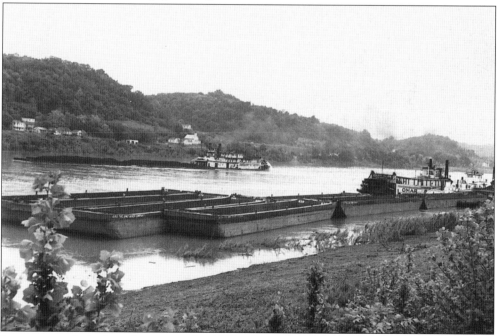

In a scene typical of riverboating in the 1950s, the steam towboat *Herbert E. Jones* is seen here pushing a string of barges loaded with coal while passing the *Omar* and the Ohio River Company landing at Huntington. Soon steampower would vanish from the river, to be replaced by more efficient diesel power.

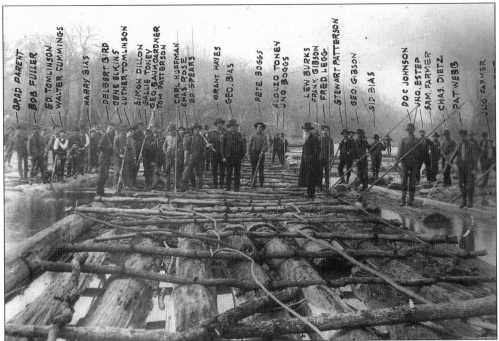

When loggers cleared the hillsides of the Guyandotte River of trees, they floated the logs downstream to the Ohio and the waiting sawmill at Guyandotte. Larger logs sometimes were floated down the Ohio to Cincinnati or Louisville. Riding herd on the floating logs was difficult and dangerous work, and those men who did it prided themselves on being tough and skilled. This photo (with the identities carefully inked in years later) is undated, but it could have been taken at almost anytime around 1900.

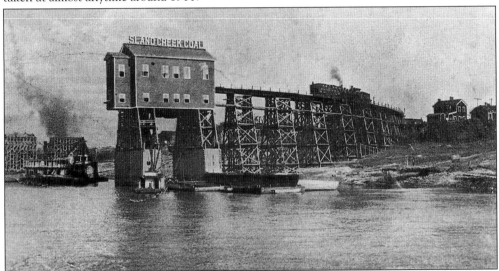

Built in 1906, Island Creek Coal Company's tipple on the Ohio River at Huntington was the last stop for the long trainloads of coal dug from the company's mines in Logan and Mingo Counties in southern West Virginia. In 1907, the tipple handled more than 329,000 tons of coal. Located just upstream from today's Harris Riverfront Park, the tipple was demolished some years ago.

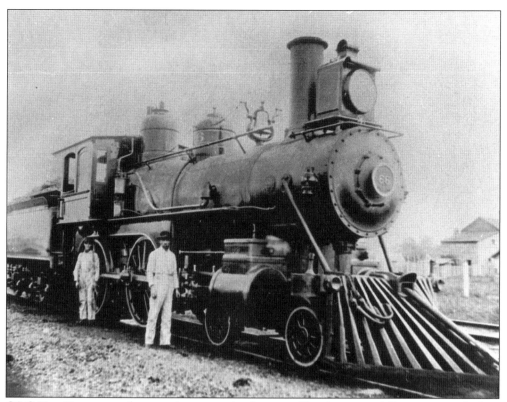

C&O No. 66 was one of two engines operating between Huntington and Cincinnati in the late 1880s. The engine is polished to perfection and you can almost hear its bell clanging. The engineer, Arch Snedegar (on the right), came to Huntington with his two older brothers from Jackson, Ohio. All three were C&O men.

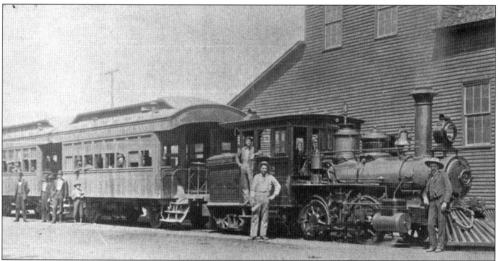

For a few years in the 1890s, the Huntington and Big Sandy Railroad ran a shuttle train that was never more than an engine and one or two coaches between Huntington and Kenova. Here the shuttle is pictured in 1892. Within a decade, the advent of streetcar service between the two communities put the shuttle out of business.

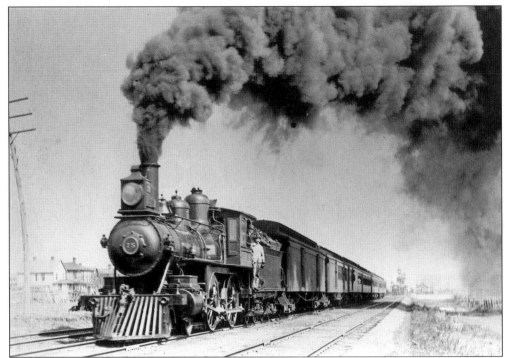

By 1899, the C&O had added two new passenger trains, the *Fast Flying Virginians*, to its line. With seven cars each—painted a bright orange and white—the new trains featured dining cars, steam heat, and electric lights. One of the new trains is shown under steam near Huntington around 1919.

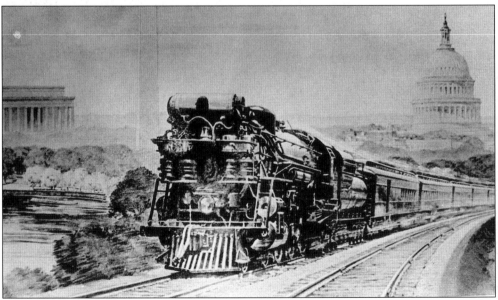

In 1932, the C&O inaugurated the *George Washington*, linking Cincinnati and Washington, D.C., via Huntington. As a young man, the nation's first president surveyed part of what eventually became the C&O right of way, so the train's name was a fitting tribute. For many years, the C&O billed itself in advertisements as "George Washington's Railroad."

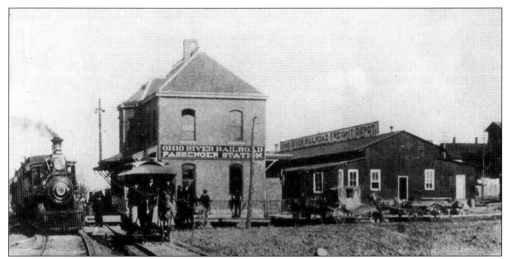

This 1892 view of the Huntington passenger and freight stations of the Ohio River Railroad was taken before that line was acquired by the Baltimore & Ohio Railroad. The unknown photographer managed to include a whole range of transportation in his viewfinder. From left to right can be seen a steam engine and three horse-drawn vehicles—a trolley, a carriage, and a freight wagon.

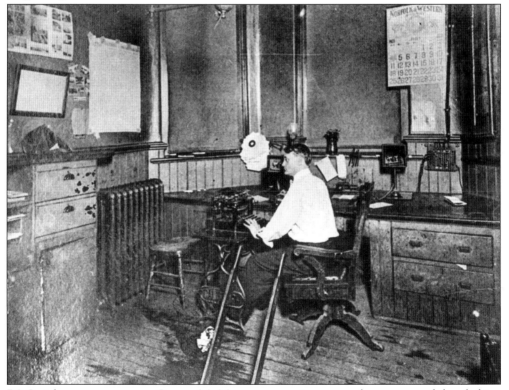

B&O ticket agent-operator George M, Moore appears intent on the message of the clicking telegraph in this 1909 photo at the old station. Note the calendar from the rival Norfolk & Western Railway hanging on the wall at upper right. The B&O station was closed in 1965 and today houses a restaurant, Heritage Station, and shops.

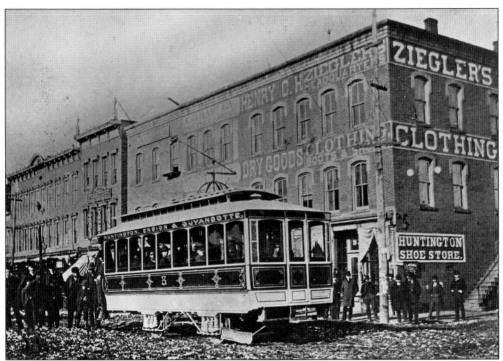

Huntington's first electric streetcar, shown here at the northwest corner of Third Avenue and Tenth Street, linked the downtown with Guyandotte. The photo is undated but the street is a sea of mud. That would put the date somewhere before 1905, when the city let its first paving contracts. The odd-looking device at the front of the car apparently was used to scrape the mud off the tracks.

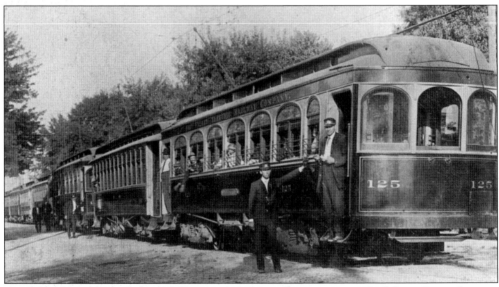

At its height in the early 1900s, Huntington's streetcar system stretched from Guyandotte to Ashland, Kentucky, and, through a ferry connection, across the Ohio River to Hanging Rock, Ohio. Shown in this 1908 photo is a special "train" of streetcars taking sports fans to a game at League Park, located on the Ohio River between West Seventh and West Eighth Streets.

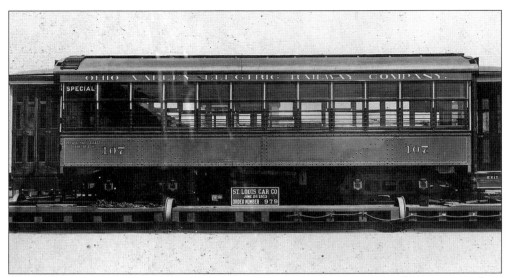

The handsome streetcar above, looking more like a railroad car than a trolley, was one of ten all-steel cars built for the Ohio Valley Electric Railway Company by the St. Louis Car Company in 1913. Organized as the Consolidated Light and Railway Company in 1888, the streetcar line later became Ohio Valley Electric, then the Camden Interstate Railway Company, then reverted to the Ohio Valley Electric name.

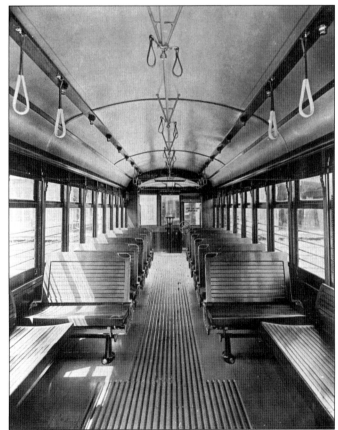

This interior shot gives a passenger's-eye view of one of Ohio Valley Electric's streetcars. The line was kept busy when West Virginia went "dry" and Kentucky was still "wet." The line had to put on extra cars to haul patrons to and from the taverns in Catlettsburg, Kentucky. Note the steering wheel at the front of the car, looking much like the pilot wheel on a boat.

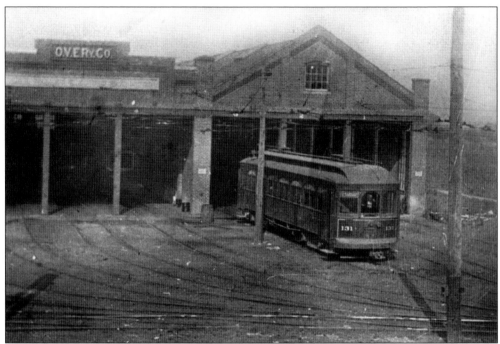

This 1918 shot of the Ohio Valley Electric Railway car barn at West Eighteenth Street shows car No. 131, a heavy wood interurban, getting ready to roll out for its early morning run. The old car barn later housed the Ohio Valley Bus Company and its fleet. Still standing, it is today home to an antique store and flea market.

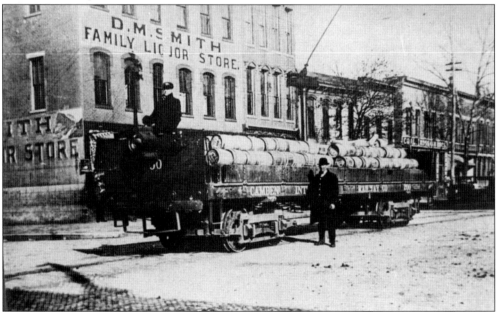

When we think of streetcars, we generally think of passengers. But the Huntington streetcar system also did a booming business in hauling freight in the young city. Here a flatcar, motorman perched atop the front, delivers a load of whiskey to the D.M. Smith Family Liquor Store on Third Avenue in downtown Huntington. The year is unknown.

Three

YEARS OF GROWTH

The County Court is peculiarly a Virginia institution. It has its origins in the monthly courts that were established in the colony in the early 1600s. When Cabell County was created in 1809, its first County Court was composed of members appointed by the governor. Their term of office was for life (or "good behavior.") When a vacancy occurred, the court's other members drew up a list of nominations and then the governor appointed someone from that list. The idea of having the court members elected didn't come along until 1850, when Virginia adopted a new constitution.

The Cabell County Court met first at a private home whose exact location isn't known, then in a simple building constructed for it at Holderby's Landing. In 1814, the court members voted to move the county seat to Barboursville, where it remained until 1863, when Confederate raids made it necessary to move it to Guyandotte. At the war's end, county government was moved back to Barboursville, but in 1887, after much controversy and litigation, Huntington became the county seat and a handsome new courthouse soon was under construction.

Construction of the courthouse was just part of the feverish activity that marked the final years of the 19th century and the first years of the 20th as the young city of Huntington grew at a rapid pace.

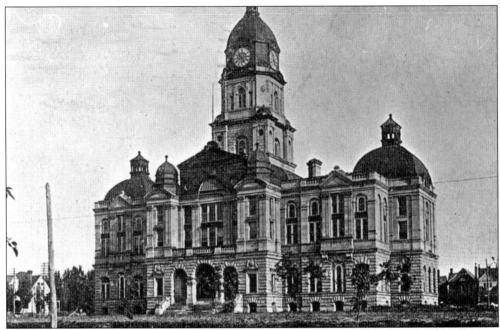

Arriving in Huntington from Barboursville, the county government first shared use of the city building and jail. (See page 36.) However, the county immediately purchased a square block of land bounded by Fourth and Fifth Avenues and Seventh and Eighth Streets as the site of a new courthouse. Its construction was delayed by the financial crash remembered as the Panic of 1893 but the cornerstone was laid in 1899 and the structure completed in 1901. This picture postcard is dated 1907.

Shown here is a west wing added to the Cabell County Courthouse in 1923. A new east wing and a separate structure housing a new jail were completed and placed in use in 1940. For a number of years, even routine maintenance at the courthouse was sadly neglected, but more recently the county has made significant funds available to help restore the old building to its once-handsome appearance.

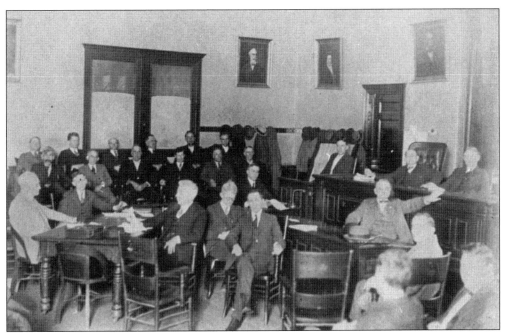

Here's a courtroom scene at the Cabell County Courthouse in 1925. On the bench at the far right of the photo is Common Pleas Judge Henry Clay Warth. He was known as a no-nonsense judge but even so was apparently willing to interrupt a trial long enough for the photographer to get this picture. Note the members of the jury, all apparently dressed in their Sunday best, arrayed at left rear.

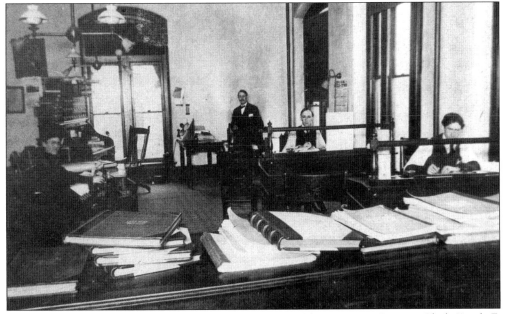

This is what the Cabell County Clerk's office looked like in 1906. County Clerk Frank F. McCullough, the man at the center of the photo wearing his suit jacket, served a remarkable four terms as county clerk, the first two from 1885 to 1897 and the second two from 1903 to 1914.

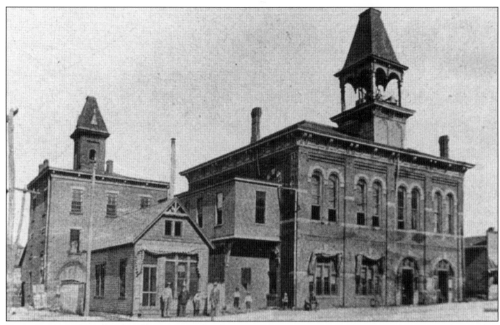

Huntington's first City Hall was a small frame building that was little more than a shed. It stood on the south side of Fourth Avenue just west of Ninth Street. In 1886, it was replaced with this building, which stood on the east side of the 400 block of Ninth Street. (This was the building that was shared with the county government pending construction of the courthouse.)

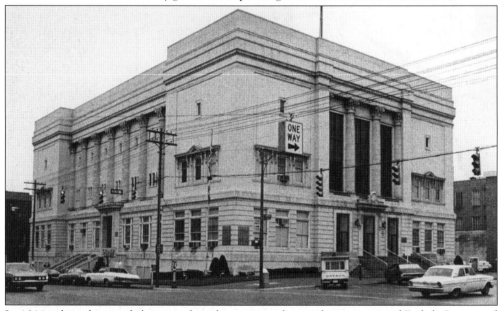

In 1911, when the city fathers purchased a tract on the northeast corner of Eighth Street and Fifth Avenue as the site of a new City Hall, they paid the unheard-of sum of $48,000. The King Lumber Company won the construction contract with a bid of $115,380. The architect was Versus T. Ritter, who also designed the old Huntington High School and the old First Huntington National Bank. Shown here in a 1972 photo, the building has changed little since its completion in 1915.

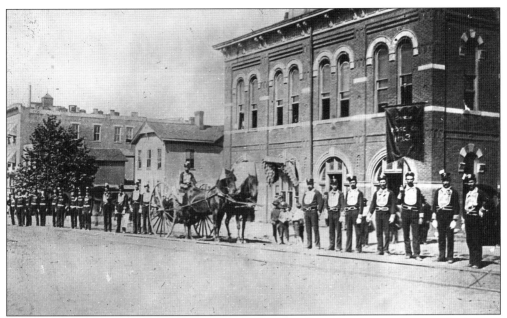

Until 1897, the Huntington Fire Department was a totally volunteer organization, broken up into rival units such as Hose Company No. 3, proudly arrayed here in front of City Hall. The city ordinance officially creating the department was approved in 1874, and the following May the city purchased its first piece of fire equipment, a secondhand, horse-drawn engine for a cost of $725.

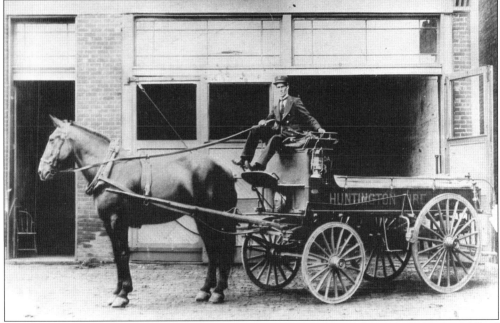

Fireman Elza Dora poses with a horse-drawn fire wagon in front of Canda Station on Third Avenue near Twenty-first Street. The year was 1910. As late as 1907, city firefighters still would be using some hand-drawn equipment, and it would be 1926 before the department would put its last fire horses out to pasture.

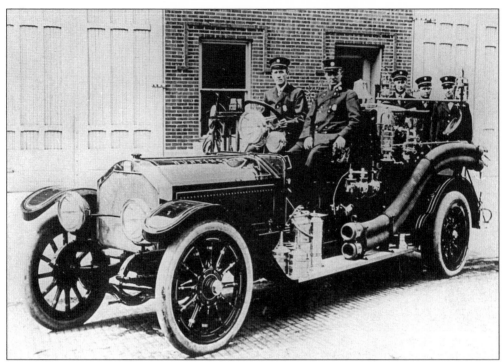

As part of a slow conversion from horse-drawn equipment, the Huntington Fire Department purchased a half dozen pieces of motorized equipment in the years from 1913 to 1917. Included were two hose trucks such as this one, shown parked in front of Central Station in the 600 block of Third Avenue.

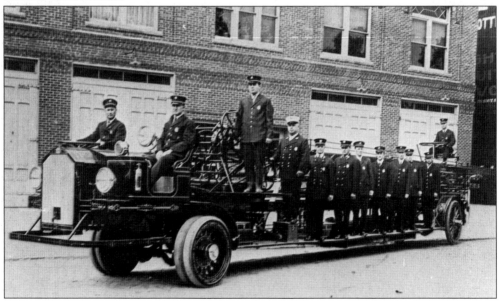

In 1917, the Huntington Fire Department purchased an 85-foot aerial ladder truck, a modern piece of fire-fighting equipment that made it the envy of other fire departments for miles around. Shown posing with a dozen of his firefighters is Fire Chief Tom Davis (at center, in the white cap). To his immediate right is Assistant Chief J.D. Booth.

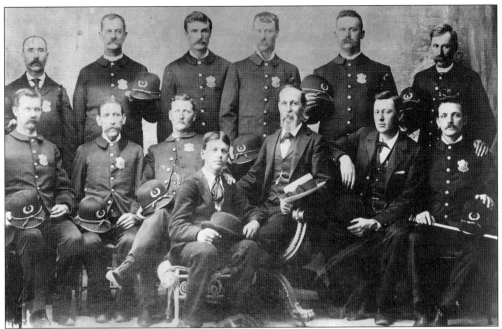

The city of Huntington had no uniformed police force until 1892. Town marshals kept the peace the best they could. Here is the assembled police force two years later in 1894. The distinguished looking gentleman at the center, with the beard and the straw hat, is Police Judge J.N. Potts, a Confederate veteran of the Civil War. Seated beside Potts, with his hand on the back of judge's chair, is Police Chief Scott Turner.

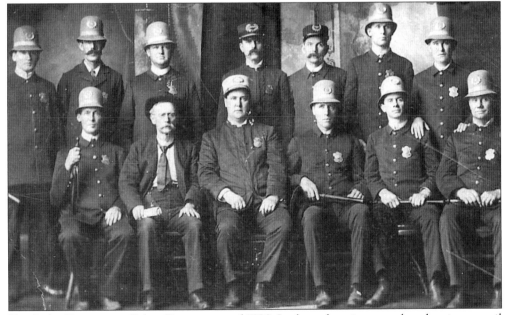

Here's the Huntington Police Department of 1900. In those days, just as today, the city council determined the number of police officers to be hired. But in an era before civil service protections were put in place, the council frequently would lop off one or two men until the next "crime wave" came along.

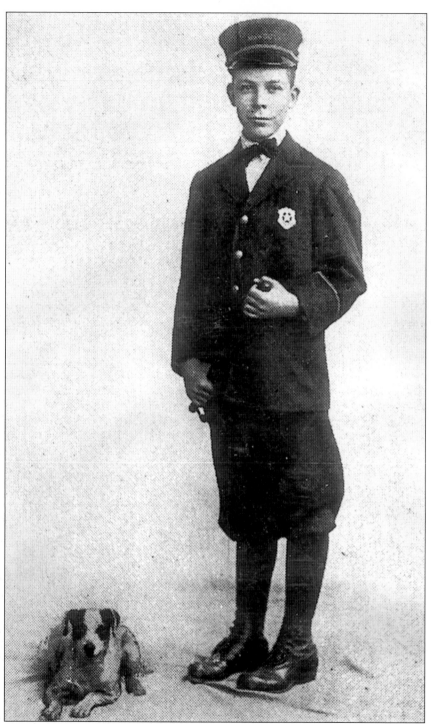

In the years just before the World War I, a youngster named Peck Moran lived next door to Huntington police chief Sam Davis, who took a liking to the boy. So when Davis organized the West Virginia Police and Peace Officers Association, he designated Moran as the organization's mascot. This photo is taken from a 1916 yearbook published by the association.

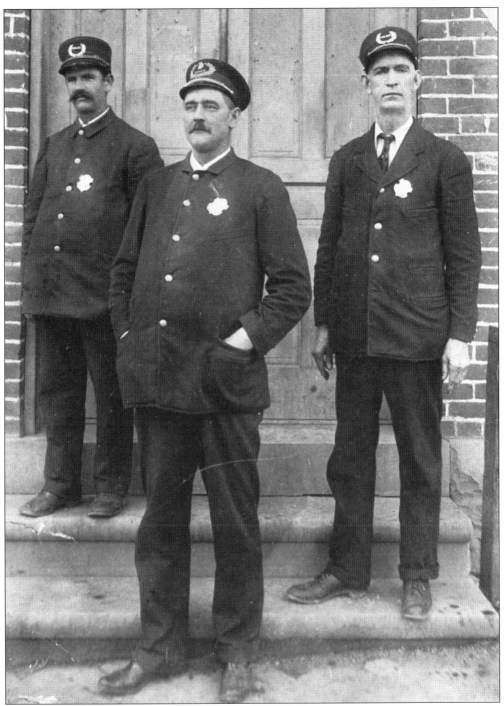

Today, Central City is simply another Huntington neighborhood but it was an independent community until 1908, when it voted to merge with Huntington. Here, posing in a 1905 photograph taken on the steps of City Hall, are all three members of Central City's police force. The building, on the corner of Madison Avenue and West Fourteenth Street, now houses Huntington's St. Cloud fire station.

With Huntington becoming an increasingly important regional center for health care today, it is hard to believe that it was 1892 before the growing city's first hospital opened. Even then it was soon forced to close it doors. It would be 1902 before the Huntington General Hospital opened its doors in the 700 block of Fourth Avenue.

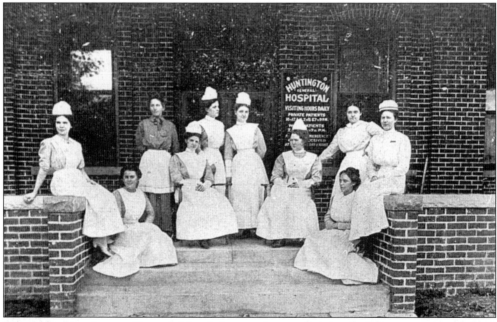

When the Huntington General Hospital opened, an adjoining building was secured for a nurses' home. Women played an important role at Huntington General. A group of prominent women regularly raised money to help cover the hospital's expenses and when it got in to financial difficulties, the men who had been in charge actually turned the hospital over to the women to operate.

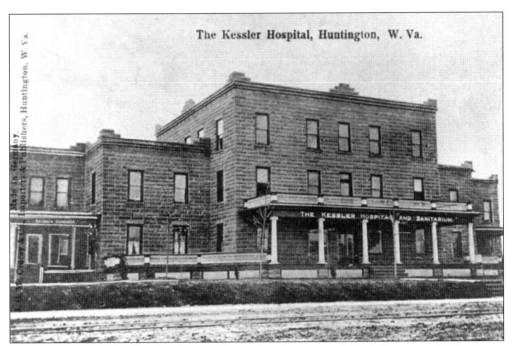

The Kessler Hospital, Huntington, W. Va.

Long a Huntington landmark, a hospital located at the corner of Sixth Avenue and First Street provided care for thousands of patients over the years. It was founded by Dr. A.K. Kessler. Other important hospitals in early Huntington included the Mount Hope Hospital and the Chesapeake & Ohio Railway Hospital for C&O employees and their families.

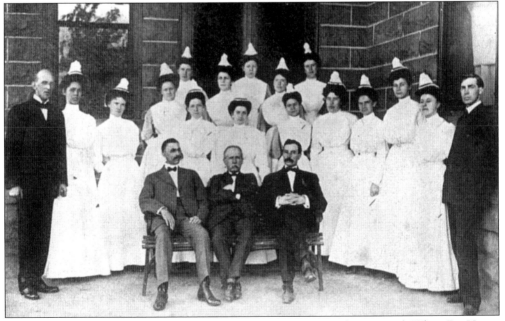

A 1907 photograph shows a class of nurses in training at the Kessler Hospital. When Dr. Henry Hatfield finished his term as governor (1913–1916), he located in Huntington and joined the Kessler Hospital, which was renamed the Kessler-Hatfield Hospital. Still later, its name was changed again, to Memorial Hospital. It closed in 1958 and was demolished shortly thereafter.

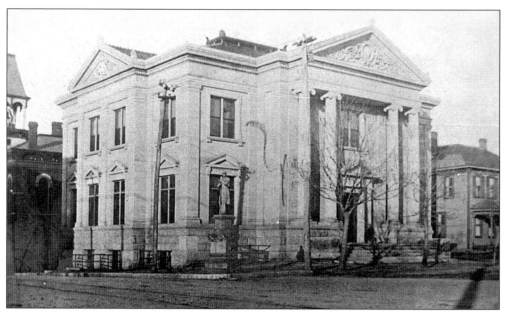

In 1901 steel tycoon and philanthropist Andrew Carnegie was helping finance the construction of public libraries all across the country. He offered $25,000 to build one in Huntington if the community would provide a site. The city gave a lot at the corner of Fifth Avenue and Ninth Street, next to City Hall, and the school board agreed to operate the library. When Carnegie's original gift proved inadequate, he agreed to donate another $10,000. The library opened in 1902.

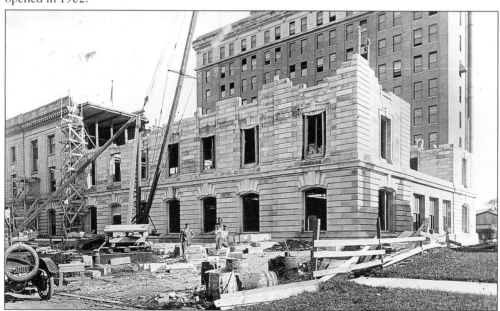

Construction started on a new U.S. Post Office and Courthouse at Fifth Avenue and Ninth Street in Huntington in 1905 and was completed the following year. In 1917–1918, an addition was built just west of the original building, as shown in this photo. A second addition was built in 1937. Today, the main U.S. Post Office is located in West Huntington, but this handsome old building still houses the District Court and various federal offices.

Four

ON THE JOB

When rail tycoon Collis P. Huntington first stood on the banks of the Ohio River and looked south to the nearby rugged hills, he envisioned a busy city. And when, soon after, he founded the city of Huntington, he worked diligently to lure to it the kind of rugged, resourceful, hard-working individuals he knew would be needed to build and sustain a thriving metropolis.

As Doris C. Miller wrote in A Centennial History of Huntington, W.Va., 1871–1971, "Considering the times and the hardships of travel, it was with amazing swiftness that men from widely diverse areas and backgrounds moved into the new city, purchased real estate, and opened businesses. They came because they believed that Huntington was destined to become a manufacturing center, with industrial plants which would require merchandise and services of many kinds."

Huntington himself never lived in his new town. His many and varied business responsibilities kept him constantly on the go, traveling almost incessantly between California, New York City, and Washington, D.C. But he was a frequent visitor, arriving via a two-car special train (one car for he and Mrs. Huntington, the other for the family servants). Even when away, the busy Huntington kept close tabs on what was happening. And surely those accounts must have pleased him because they pictured a new town that was growing at an almost explosive rate.

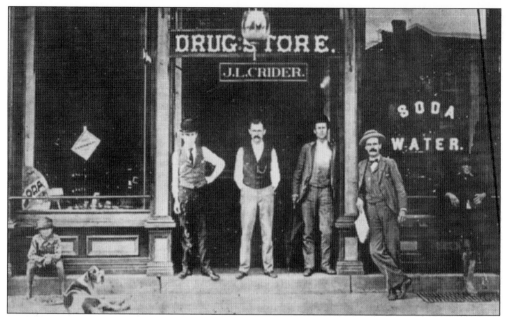

J.L. (Jake) Crider came to Huntington from Ohio in the early 1870s and immediately opened a drugstore. Located on the north side of Third Avenue between Tenth and Eleventh Streets, it was a popular gathering spot in the young city. Other early druggists in the young town included T.N. Boggess, John Lowry, W.S. Vinson, and Herman Wild.

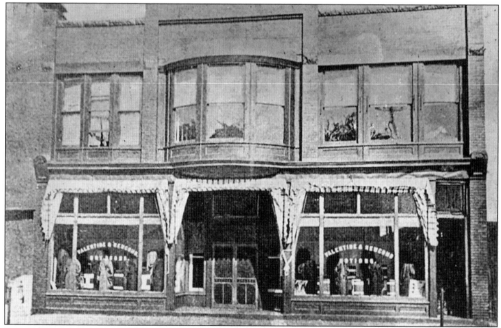

In 1895, John W. Valentine and W.H. Newcomb opened a department store, shown above, in the 300 block of Ninth Street. The store prospered and the partners built a three-story building around the corner on Third Avenue. In 1907, Valentine sold his interest to E.G. Newcomb and the store's name was changed to the Anderson-Newcomb Company, a name that would become a household word to generations of local shoppers.

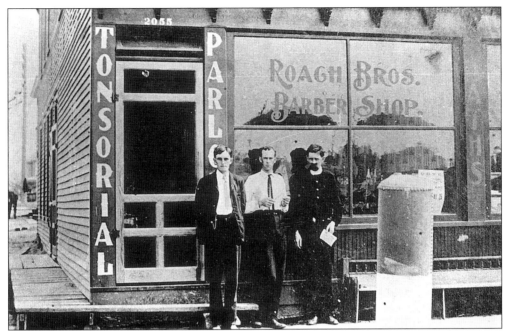

In the 1880s, when haircuts cost a quarter and shaves went for a dime, Huntington boasted more than a dozen barbershops. In this 1907 photo, barber Sam Roach (at center) poses in front of his tonsorial parlor at 2055 Third Avenue. Besides haircuts and shaves, the sign at far right indicates the shop also offered baths.

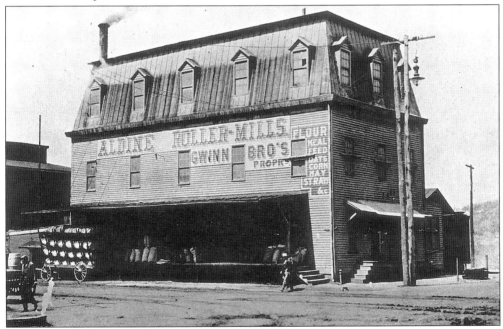

In 1889, the Gwinn Brothers (E.E. and W.W.) moved their busy flour mill from Glenwood, West Virginia, to Huntington, locating at the corner of Third Avenue and Tenth Street. When the size of the mill proved inadequate to the demand, a new, larger mill was erected at a site just west of the old one. The new mill went into operation in April of 1904.

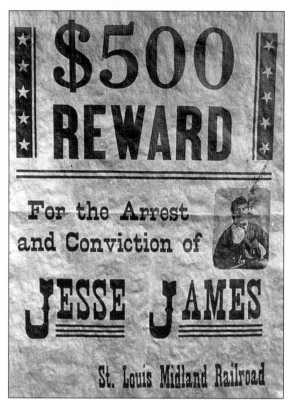

The Bank of Huntington, the city's first, opened its doors at 1208 Third Avenue on September 2, 1872. Almost three years later to the day, on September 6, 1875, bandits robbed the bank, getting away with loot variously put at $2,000 to $20,000. Local legend credits the infamous Jesse James with the holdup, but evidence for that is scant. The robbery, however, may have been the handiwork of Jesse's lesser-known brother, Frank.

The Bank of Huntington got some competition when the First National Bank was chartered in 1884. It was housed in this impressive stone building, which stood on Third Avenue between Eighth and Ninth Streets. In 1891, the Commercial Bank was founded and three years later merged with the Bank of Huntington to form the Huntington National Bank.

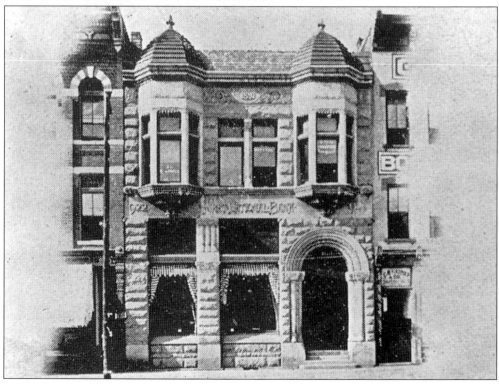

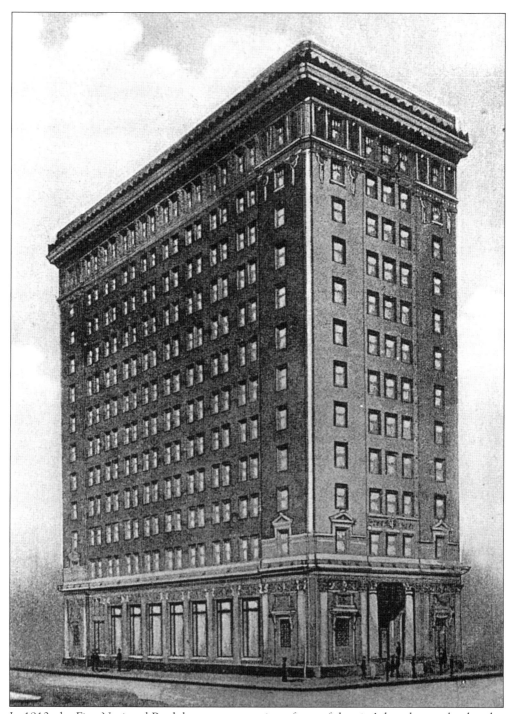

In 1912, the First National Bank began construction of one of the city's best-known landmarks, a 12-story building on the southwest corner of Fourth Avenue and Tenth Street. The Huntington National and First National were the community's primary banks until their 1924 merger, which created the First Huntington National Bank. Today it is part of Bank One and is located in the 1000 block of Fifth Avenue. This building is now home to Fifth Third Bank.

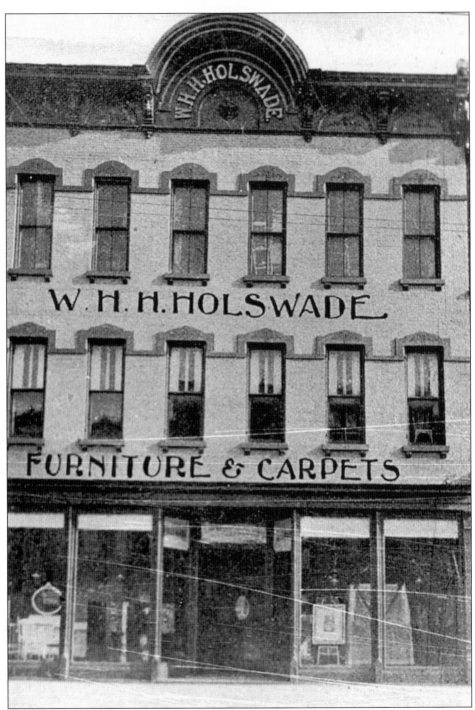

William Henry Harrison Holswade first worked as a postal clerk, then tried his hand at running a cigar stand, before going into the furniture business. In 1875, he formed a partnership with J.H. Poage and opened a store at 945 Third Avenue. Two years later, he bought Poage's interest. Holswade was a Mason, an Odd Fellow, president of the Huntington Chamber of Commerce, and a member of the school board.

Like most furniture dealers of his era, W.H.H. Holswade also acted as an undertaker. It was not unusual in those day to find coffins for sale in the undertaking department side by side with rocking chairs and kitchen tables. Holswade used this drawing of a hearse as an advertisement on his letterhead and receipts in the mid-1880s.

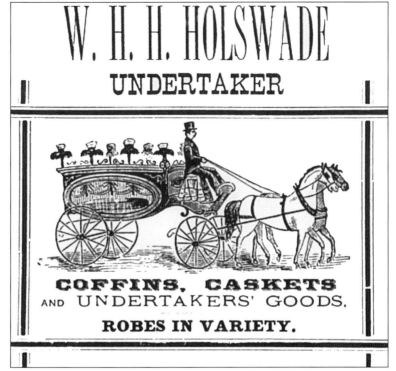

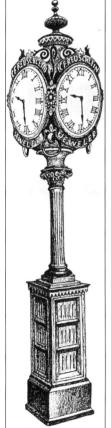

When H.J. Homrich opened his Third Avenue jewelry store in 1892, he looked for a distinctive sign. What he came up with was a 20-foot-high cast-iron clock. Today, the clock stands in front of C.F. Reuschlein Jewelers Inc., successor firm to Homrich, at 825 Fourth Avenue. In 1968, a truck sideswiped the clock, toppling it to the ground. But after ten months of repair work, it was restored to its familiar place.

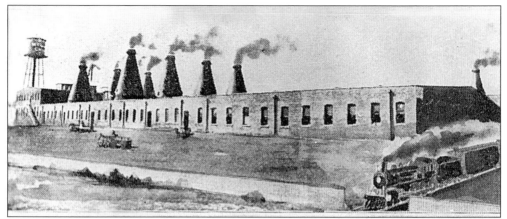

Opened on what is now Hal Greer Boulevard in 1904, the Huntington China Company went bankrupt in 1907 and was sold to satisfy its creditors. The buyer, Harry R. Wyllie, had grown up in East Liverpool, Ohio, and as a boy worked in his father's pottery business. Renaming the company the H.R. Wyllie China Company, he ran it successfully for more than 20 years. He died in 1931 and his widow closed the plant a few years later.

Huntington was nearly 50 years old before its largest industrial employer appeared on the scene. In 1921, the International Nickel Company picked a corn patch just south of Guyandotte for construction of a new $3.5-million refinery and rolling mill. Posing here with the first ingots poured in 1922 are, at center, the new plant's superintendent, Arthur S. Shoffstall, and his assistant, H. M. Brown. The man on the right is unidentified.

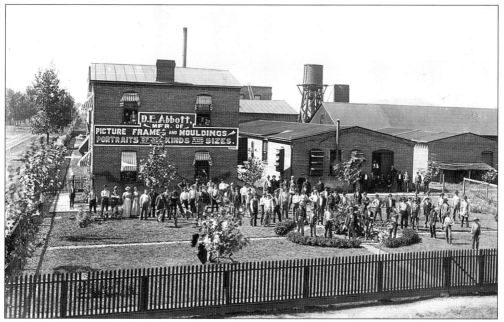

D.E. Abbott came to Huntington from Vermont, completed his education at Marshall College, and started out in life as a photographer. His business proved successful and he began to enlarge and duplicate pictures, then opened a picture frame plant in Central City. In this photo of unknown date, employees of D.E. Abbott & Company pose for the camera. Who knows? The cameraman may well have been Abbott himself.

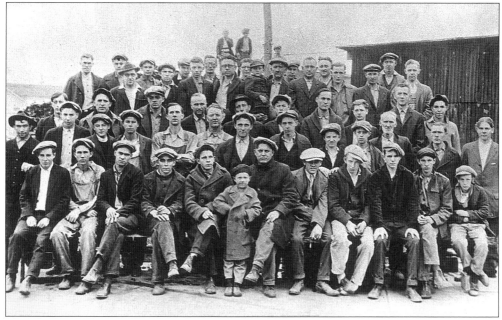

In 1891, L.H. Cox and some associates opened a bottle factory in Central City. The plant changed hands several times and eventually became the Huntington Tumbler Company. This 1923 photo shows the assembled plant workers and an unidentified young child in the center of the front row. The plant ceased operation in 1932.

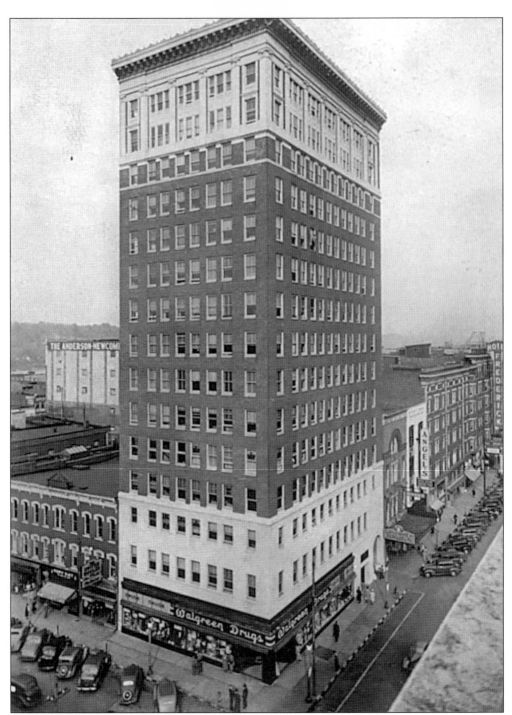

The 15-story West Virginia Building dominates the Huntington skyline. Located at the northwest corner of Fourth Avenue and Ninth Street, it was built in 1925 and at that time was the tallest building in the state. Walgreen Drugs occupied the ground floor retail space for many years, as shown in this postcard view, dating from the 1930s. Today, the building is owned by Huntington businessman Huey Perry.

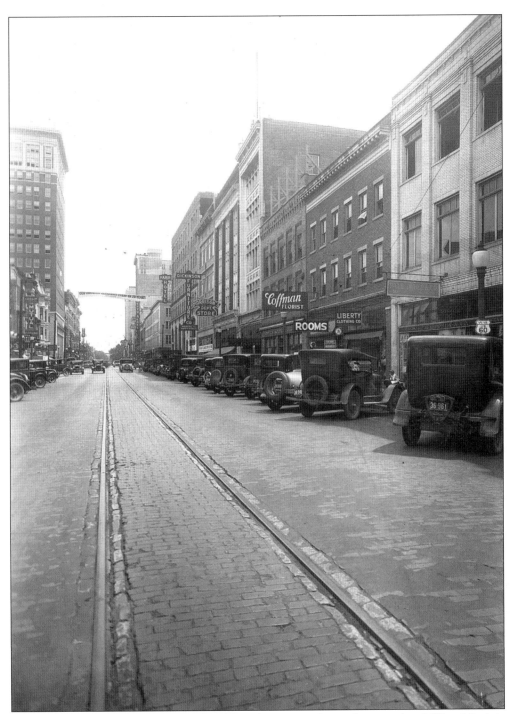

This Huntington street scene is undated but, because it shows the completed West Virginia Building at left, we know it was taken sometime after 1924. The photographer was looking east from Eighth Street. Signs on the right-hand side of the street identify several businesses, including Coffman Florist, O.J. Morrison's Department Store, Dickinson's Furniture Company, and the Farr Hotel.

In 1912, two Tiffan, Ohio business partners, Henry Dourif and Omar T. Frick, acquired half an acre of land on Fifth Avenue just east of the Baltimore & Ohio Railroad crossing and built a plant for the manufacture of ultramarine blue dye. The plant employed 20 people when it started operation. From that small beginning, the business steadily grew and Standard Ultramarine and Color Company, or SUCO, as it was generally called, became one of theregion's biggest and best-known industries. Because the plant sprawled over both sides of Fifth Avenue, traffic on the avenue sometimes had to stop while workers—many of them covered from head to toe in blue dye—made their way across the busy roadway. Over the years, many of the buildings shown here have been demolished and the plant has changed hands several times. It is now owned by BASF, a German firm.

The availability of steel and a "good labor market" attracted Houdaille-Hershey Corp. to Huntington, and in 1946 it established a plant for the manufacture of chrome-plated automobile bumpers. At its peak, the plant employed 900 workers and produced 9,000 bumpers per day. Federal safety regulations and fuel-economy requirements forced the auto industry to change to lighter bumpers and essentially put the plant out of business. It closed in 1980.

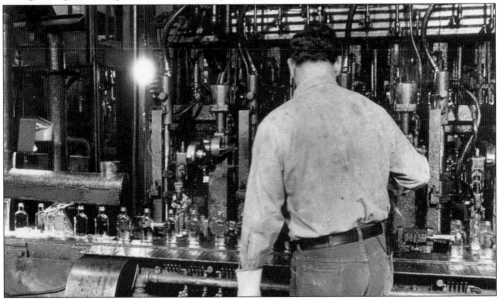

Inexpensive natural gas lured Charles Boldt to Huntington from Cincinnati. In 1913, Boldt built a gas-fired bottle plant on the south side of the Chesapeake & Ohio tracks at Fifth Street West. Later the plant was purchased by what came to be the Owens-Illinois Glass Company. The plant once boasted five furnaces and a workforce of more than 1,100. Competition from foreign makers and plastics forced its closure in 1993.

Five

BUGGIES TO MODEL-TS

Cabell County is a bit less than 200 years old. Today, we take for granted jet airliners and space shuttles and sometimes forget that when county seats were established the prevailing thinking of those in government was that no courthouse should be more than a day's ride by horseback, wagon, or carriage from any of its citizens. That's how it is that West Virginia, while a small state, nonetheless has 55 counties.

It's also worth recalling that when construction started on the Huntington end of the C&O, the lure of a well-paying job on the railroad attracted hundreds of men from a huge radius around the new town. Many men walked for days to reach Huntington. One such man, the Rev. Nelson Barnett, walked from Buckingham County, Virginia, to Huntington. Arriving, he found a bustling town that clearly needed workers. He returned to Virginia and brought back a wagonload of fellow African Americans to work for the C&O.

Skip ahead just a few years and you find the ultimate in transportation in Huntington and Cabell County evolving from the familiar horse and buggy to new-fangled automobiles, trucks, and even—for the more adventuresome—motorcycles. And no matter the mode, people were always willing to pose for the camera.

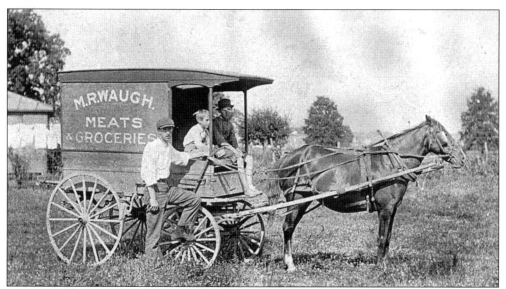

The year was 1911 and driver Ed Smith was on his way to make a delivery for M.R. Waugh Meats & Groceries. But some housewife had to wait a bit longer for her order when Smith and his young companions stopped to pose for a photographer. Seated in the wagon are, from left to right, Ed's son Paul and Paul's friend, Ernest Rood. The photograph was taken at Ninth Avenue and First Street on Huntington's South Side.

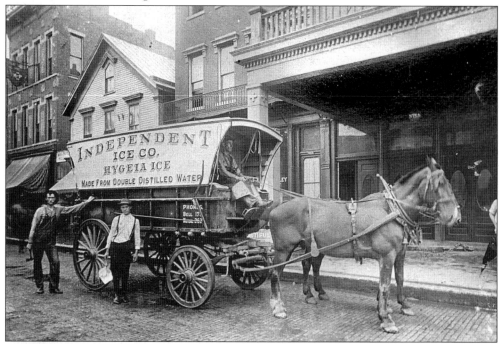

A wagon of the Independent Ice Company pulls up on the newly bricked Third Avenue to make a delivery at the old Huntington Theater at the corner of Eighth Street. A faded newspaper clipping identifies the boy holding a block of ice as Fred "Penny" Bailey. The man with him is unidentified. City records identify at least two other early ice companies in Huntington—City Ice Delivery and M.W. Eckhart Ice.

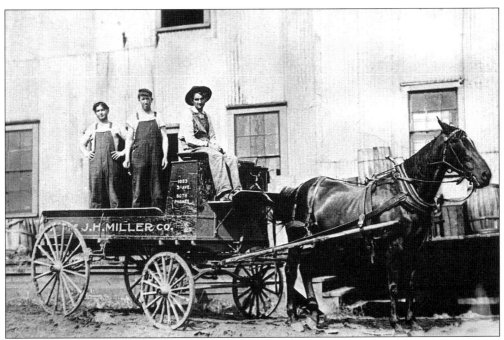

The bold lettering along the side of this wagon identifies it as belonging to the J.H. Miller Company. The location and the year the photograph was taken are unknown. The Miller Company was a wholesale china and glassware dealer, part of the once thriving wholesale industry in Huntington and Cabell County. Goods from wholesale warehouses were shipped by rail to coalfield communities throughout southern West Virginia.

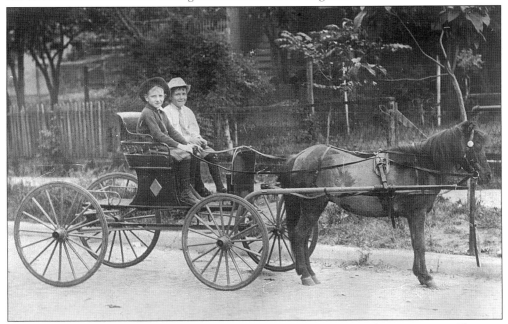

Here is an interesting c. 1913 shot of two boys taking a ride in a handsome carriage. They are said to be Ernest Layne, left, and Garner Berlt. The photo is thought to have been taken in the 400 block of Sixth Avenue.

Many people in the Huntington of 1908 may have placed a call to the cab company, Union Transfer & Storage Company, when trying to get somewhere in a hurry. While no detailed information on the company and its cab operation has come down to us, it must have done a good business to justify the expense of printing postcard advertisements such as this one.

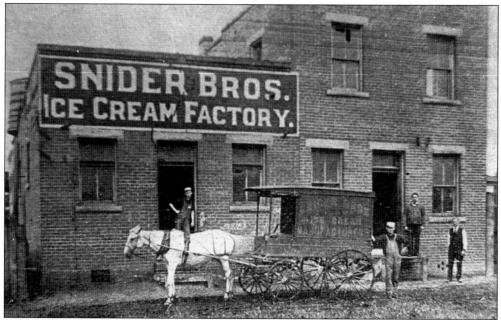

This photograph is reproduced from a 1910 Huntington Chamber of Commerce booklet extolling the virtues of the city. According to the booklet, the Snider Bros. Ice Cream Factory on Seventh Avenue was established in 1891 and was "the pioneer ice cream factory of Huntington." The company was said to operate two delivery wagons such as this one and employ eight men.

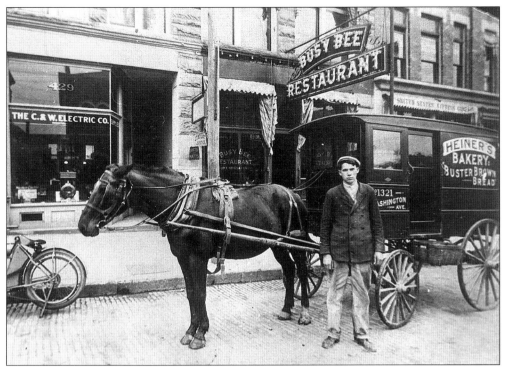

J.W. Milstead poses for the camera while delivering Heiner's "Buster Brown" brand bread to the Busy Bee Restaurant at 427 Ninth Street. When C.W. Heiner first started baking bread in 1905, he sold it by carrying a basket of loaves from door to door. Later, the firm used one-horse wagons such as this one to deliver its bread. Heiner's continues in business today, now as part of the Sara Lee organization.

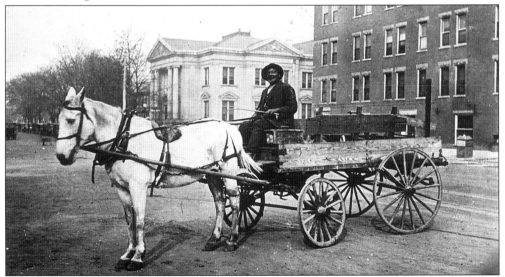

In his *Cabell County Annals and Families*, George Selden Wallace wrote that Dan Hill "began life as a train porter on the Chesapeake & Ohio Railway and in some way he lost an eye and then embarked in the cab business." Visible behind Hill in this photo is the Cabell County Public Library, which was opened in 1902, placing the photograph's date sometime later.

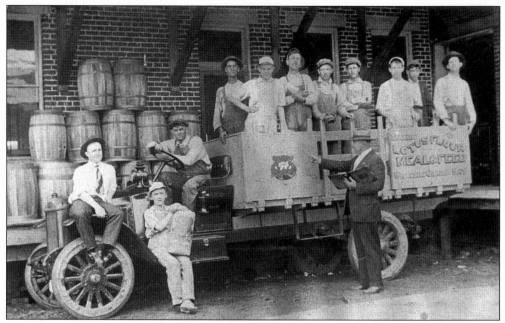

In 1916, a group of workers at the Gwinn Brothers Mill in downtown Huntington proudly pose with the firm's stakebed truck. Note the sign on the truck advertising "Lotus Flour Meal and Feed." After more than 60 years of operation, the old mill closed in the 1960s and in 1970 became the first building demolished as part of the Huntington Urban Renewal Authority's downtown redevelopment project.

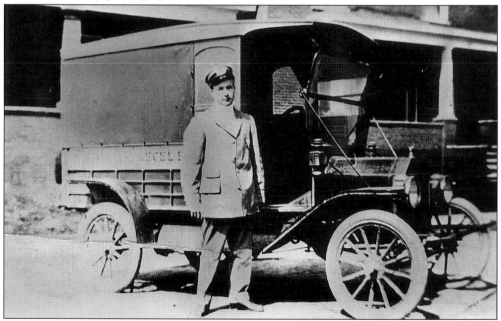

Huntington postman Dana D. Shank poses with a U.S. Mail truck, which was used to make parcel post deliveries. When this photo was reprinted by the *Huntington Advertiser* in 1972, Shank told the newspaper that the truck was a 1913 Ford roadster that had been converted into a truck at a local blacksmith shop.

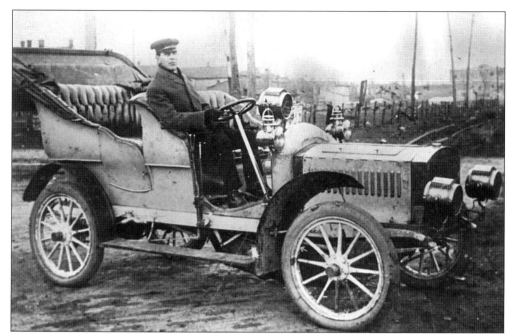

In the early days of automobiles, some drivers bought recognized brands while others had cars especially built for them. Shown at the wheel of his "Gray Goose," said to be the first car built in Huntington, is Walter Hambrick, clad in a spiffy jacket and cap. The car was built by Eustace Clark at the old Ingram and O'Neill Machine Shop at Second Avenue and Tenth Street.

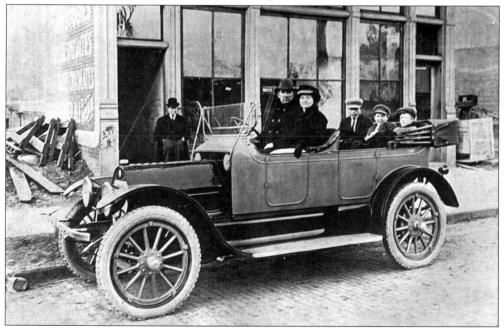

This impressive-looking touring car, parked in front of a candy and cigar store in 1914, is an Apperson Jack Rabbit. It was owned by Mr. and Mrs. Ira E. Flesher, who are in the front seat. Among the youngsters in the back seat is Maxwell W. Flesher, who grew up to be an attorney and represented the city for a number of years.

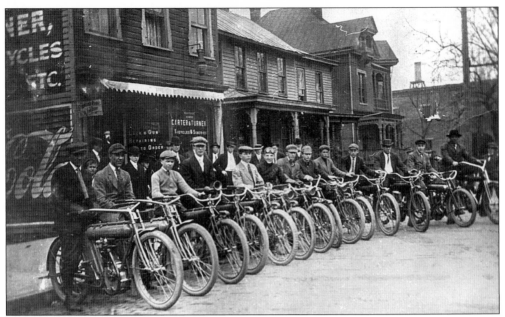

Sunday afternoons were more leisurely in 1910 when these members of the Huntington Motorcycle Club, more than a dozen strong, gathered in front of Carter and Turner's Bicycles and Sundries shop prior to taking off on an outing. The shop, popular with early motorcycle owners, was located at Fourth Avenue and Eleventh Street.

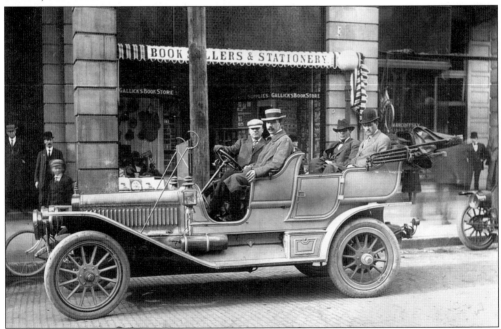

James Arthur Garner is shown at the wheel of his four-cylinder Winton 6 automobile, purchased in the fall of 1909 and credited by George Selden Wallace with being the first automobile in the city of Huntington. The car is shown parked in front of Gallick's Book Store in the 900 block of Fourth Avenue. Note the gas tank located above the running board for fueling the headlights.

Six

THE GOOD LIFE

Over the years, those visionary individuals who built the factories, stores, and other businesses that were the economic lifeblood of Huntington and Cabell County did more than that—much more. They built schools and churches, parks and theaters, hotels and restaurants. They formed sports teams, musical groups, luncheon clubs, and a host of other organizations. And, of course, they nurtured what would become a great university.

The county's first settlers immediately built both schools and churches, recognizing that both were essential parts of any community. Rufus Cook, the Boston surveyor hired by Collis P. Huntington to lay out the rail baron's new town, made no provision for a public park or even a public square anywhere. So agitation began almost at once for construction of a public park. After several abortive starts, Ritter Park, dedicated in 1913, became one of the most popular pieces of real estate anywhere in the county. Even if young Huntington was without a park, there were many other ways for residents to spend their free time. From the city's earliest years, theater and vaudeville attracted large enthusiastic audiences.

To their credit, those early residents did all the things necessary to make Huntington and Cabell County, not just a good place to earn a good living, but one where people could put down roots, raise families, and enjoy the good life.

Cabell Elementary School was new and part of the independent Central City school system when this photograph was made in 1897. At center is Principal P.W. Cooper, surrounded by the school's half-dozen female teachers. The school at 1030 Adams Avenue was much expanded when it later became part of the Cabell County system.

Like Central City, Guyandotte operated its own schools until its 1911 decision to become part of the city of Huntington. Here, looking much like a dance card from a fancy ball, is a souvenir of the 1901–1902 school year at Guyandotte Public School. Note the brevity of the school year, which apparently started in December and ended in April.

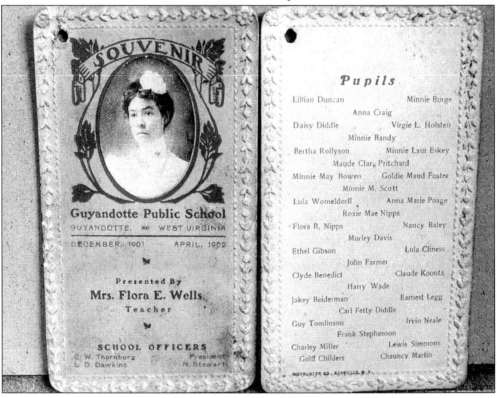

SOUVENIR

Guyandotte Public School

GUYANDOTTE, ※ WEST VIRGINIA

DECEMBER, 1901 APRIL, 1902

Presented By
Mrs. Flora E. Wells,
Teacher

SCHOOL OFFICERS

C. W. Thornburg President
L. D. Dawkins N. Stewart

Pupils

Lillian Duncan	Minnie Burge
Anna Craig	
Daisy Diddle	Virgie L. Holsten
Minnie Bandy	
Bertha Rollyson	Minnie Laur Eskey
Maude Clare Pritchard	
Minnie May Bowen	Goldie Maud Foster
Minnie M. Scott	
Lula Womeldorff	Anna Marie Poage
Roxie Mae Nipps	
Flora B. Nipps	Nancy Baley
Murley Davis	
Ethel Gibson	Lula Cliness
John Farmer	
Clyde Benedict	Claude Koontz
Harry Wade	
Jakey Beiderman	Earnest Legg
Carl Fetty Diddle	
Guy Tomlinson	Irvin Neale
Frank Stephenson	
Charley Miller	Lewis Simmons
Golff Childers	Chauncy Martin

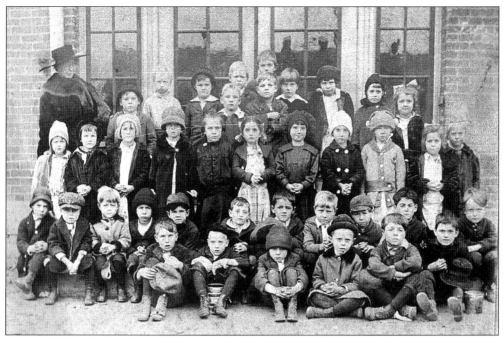

The pupils above, many of them bundled up against what must have been a cold day, comprised the second grade class at Cabell Elementary School during the 1916–1917 school year. Miss Lillian Capon Bienkampen, at upper left in the photo, was the teacher. Originally built in 1896, the school was extensively remodeled in 1914.

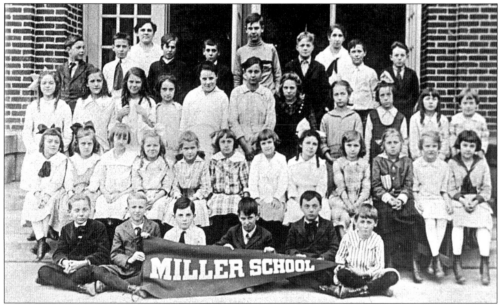

A pennant held by the boys seated in the front row of this old photograph leaves no doubt which school is pictured here. It's Miller Elementary School at Twelfth Avenue and Seventh Street on Huntington's South Side. A penciled note with the photo indicates that the year was 1917 and the pupils pictured were fourth graders. The principal is identified as "Miss Carter" and the teacher as "Miss Thornburg."

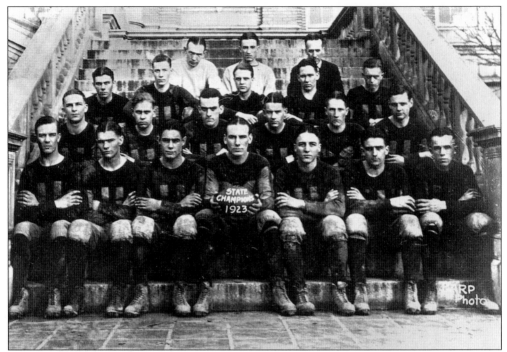

Posed on the school's historic front steps, this Huntington High School football team won the West Virginia state championship in 1923, a fact attested to by the white lettering neatly applied to the ball held by one of the players. Completed in time for the 1916–1917 school year, Huntington High would be the city's only high school until Huntington East High was built in 1940.

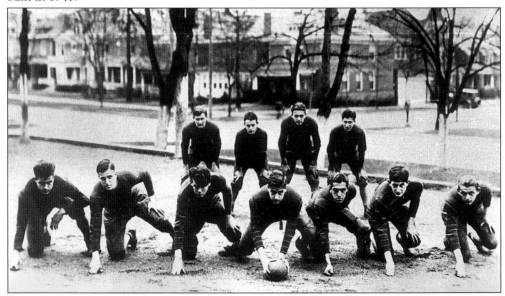

Members of the 1928 football team at Huntington's St. Joseph Catholic High School are shown as they posed for a team shot during a practice session. The school was founded by Father Henry B. Altemeyer (later Monsignor Altemeyer), who served the St. Joseph parish for 32 years, from 1898 until his death in 1930.

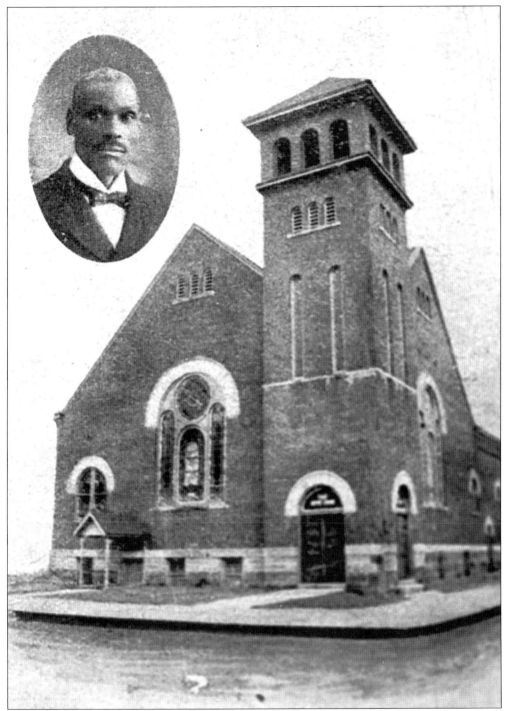

Shown here is the original building of the First Baptist Church on the southeast corner of Sixth Avenue and Eighth Street. The inset at top left shows the Rev. I.V. Bryant, who was the church's pastor from 1911 to 1932. Today, the Huntington congregation remains a focus of religious and social life for many members of the local African-American community.

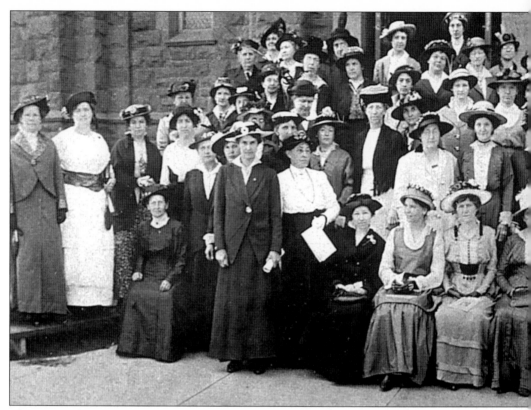

This 1915 photograph shows the women of the Treasure Seekers Bible Class at Johnson Memorial Methodist Church, each wearing a carefully chosen hat. Huntington is often called

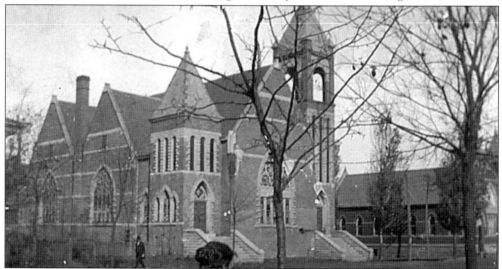

The Fifth Avenue Baptist Church has always been on Fifth Avenue, but not always at its present Twelfth Street location. This photograph, thought to have been taken sometime shortly after 1900, shows its original sanctuary. When the congregation moved, Col. J.H. Long bought the property, demolished the old church, and built the building that today is home to *The Herald-Dispatch*.

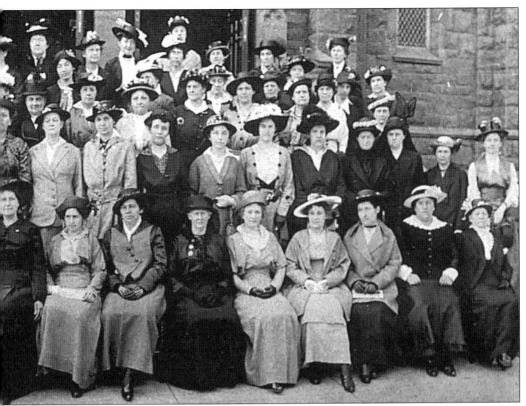

the "City of Churches" because it is home to so many congregations, including Johnson Memorial and five others in a short stretch of downtown Fifth Avenue.

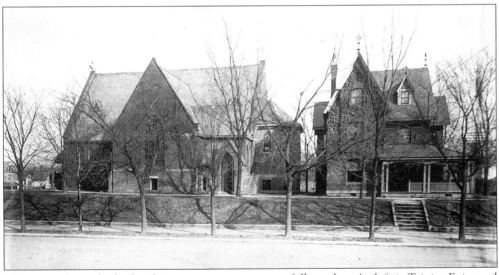

This scene is no doubt familiar, yet strange, to many folks today. At left is Trinity Episcopal Church at Fifth Avenue and Eleventh Street. Standing beside it is an old house, later demolished to make way for construction of a parish hall. The date of the photo is unknown, but the brick paving on Eleventh Street indicates the date was sometime after 1900, and the bare trees tell us it was winter.

Modern-day feminists may find it interesting to note that this group of more than 50 dignitaries photographed at the September 11, 1913 opening of Huntington's Ritter Park contains not one woman. The park was fashioned from land originally bought by the city as a site for an

Although the park was named for C.L. Ritter, Mayor Rufus Switzer (1855–1947) was the architect of the deal that created Ritter Park, enjoyed by countless generations of residents in the decades since. Described by those who knew him as a tall, lanky man with a lively sense of humor, Switzer was a well-liked and respected lawyer, banker, and political leader.

incinerator. Neighbors understandably objected to the idea and when lumberman C.L. Ritter offered to donate additional land if the total tract was used for a park, the city took him up on his offer.

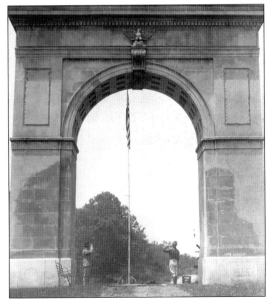

Dedicated on Armistice Day in 1924, this handsome arch in Memorial Park on Huntington's South Side was erected by the Cabell County War Memorial Association and dedicated to the men of the county who served in what was then called the "Great War," known to us today as World War I. Badly damaged by weather over the years, the arch was recently renovated and re-dedicated.

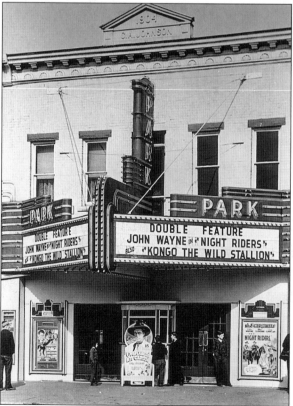

From its opening as the Davis Opera House in 1895 until its closing in 1928, the Huntington Theater hosted many of the most famous names in show business. The old theater is shown here in a 1939 photograph as work got underway to convert the building for use as a Montgomery Ward store.

The Abbott, Westmor, Waco, Park, Uptown, Mecca, and Beverly were all neighborhood theaters that once attracted Huntington moviegoers. The Park, shown in this photo thought to have been made in 1940, was located in the 2000 block of Third Avenue. It welcomed generations of youngsters to its double-feature cowboy movies. All the neighborhood theaters—victims of changing tastes in entertainment—are long gone.

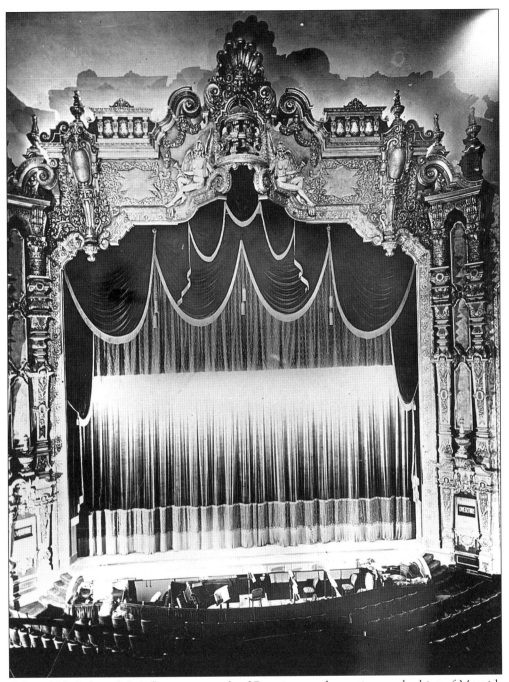

A bit of Michelangelo's influence, a touch of Renaissance decoration, and a hint of Moorish architecture were combined in the opulent interior of the Keith-Albee Theatre. Originally budgeted at $350,000 to $400,000, construction of the motion picture palace eventually ended up costing more than $2 million. Built in the 900 block of Fourth Avenue, the Keith has been delighting audiences since 1928.

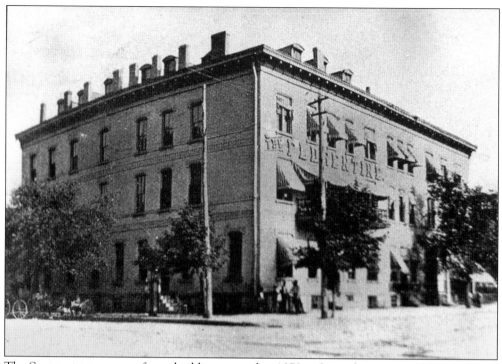

The Scranage, a two-story frame building erected in 1872 at Second Avenue and Ninth Street, is said to have been Huntington's first hotel. Other pre-1900 hotels included the Ware and the Breslin. But the premier hotels in the city's early years were the Adelphi and, shown above, the Florentine, which opened in 1887 on the corner of Fourth Avenue and Ninth Street. It was demolished in 1933.

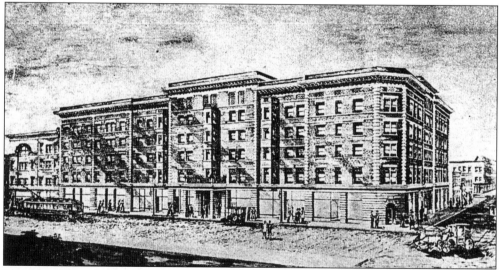

Some 3.5 million bricks; 4,000 electric light bulbs; 252 miles of electrical wire; 200 telephones, and 5 railroad cars of glass are said to have gone into construction of the Hotel Frederick. The plush hotel welcomed its first guests in 1906 and would be a center of the county's social life for more than 50 years before closing its doors. Today, the Frederick houses stores, offices, and apartments.

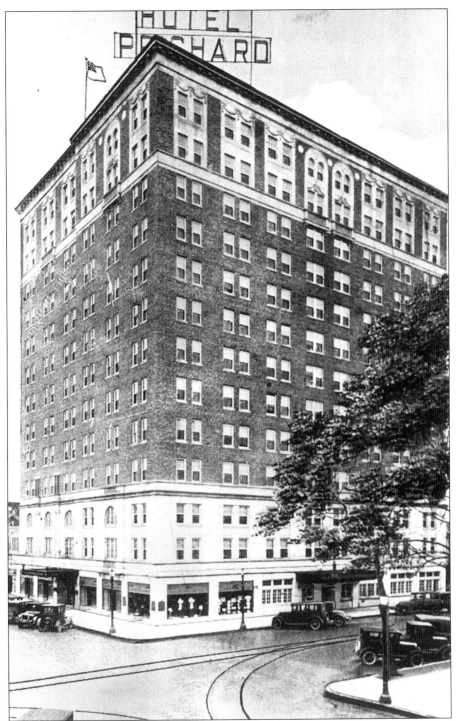

The 13-story, 300-room Prichard Hotel, built by developer Fred C. Prichard, opened at Sixth Avenue and Ninth Street in 1926, and this penny postcard view was taken shortly thereafter. Prichard also constructed the Robson-Prichard Building, located just a half block north on Ninth Street. The Prichard Hotel ceased operation in 1970.

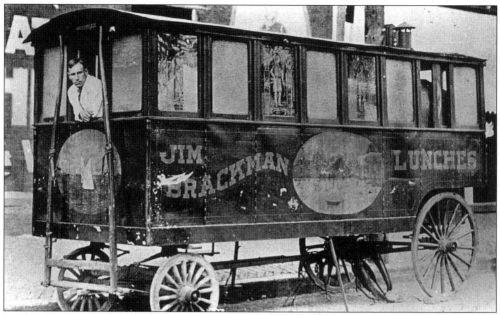

In the years just after World War I, Jim Brackman is said to have sold as many as 800 hamburgers a day from his several lunch wagons strategically stationed around downtown Huntington. Jim's son, Howard, is shown here in a rare moment of relaxation, waiting for the next rush of hungry customers.

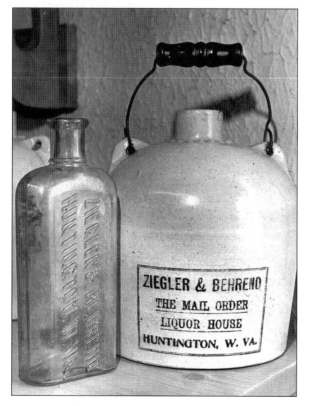

Although Huntington's Ziegler & Behrend ("The Mail Order Liquor House") had plenty of competition from moonshiners in southern West Virginia, old-timers recall that the firm's jugs and bottles were a familiar sight in the coalfields in the late 1890s and early 1900s.

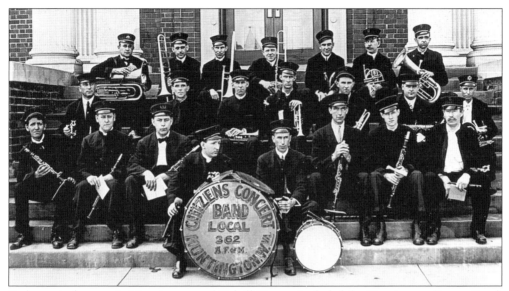

Early musical groups in Huntington and Cabell County included the Huntington Cornet Band, which was formed in 1874; the Guyandotte Brass Band of the 1880s; and, shown here, the Citizens Concert Band. Sponsored by Local 362 of the American Federation of Musicians, it was one of the most popular bands of its days, especially at summer dances.

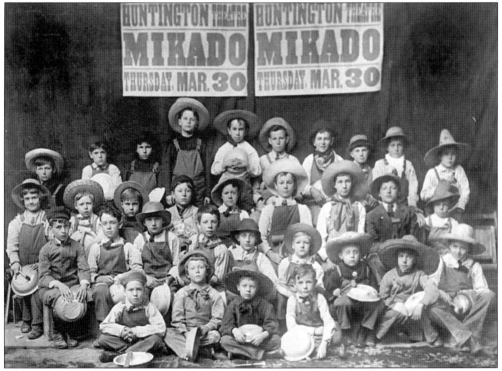

The year was 1911 and the place the Huntington Theatre (see page 76) as this youthful but enthusiastic cast prepared to present its own version of *The Mikado*. Indeed, this may be the only production of the popular operetta ever done that featured a Lord High Executioner wearing bib overalls.

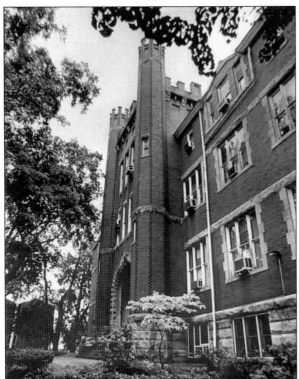

Marshall University traces its origin to 1837 when residents of Guyandotte and the surrounding area met at the home of lawyer John Laidley, planned the school, and agreed to name it Marshall Academy in honor of Laidley's friend, Chief Justice John Marshall. Old Main is the school's oldest building, but it is actually five buildings constructed at different times. The familiar front of the building shown here is the newest part, built in 1905–1906.

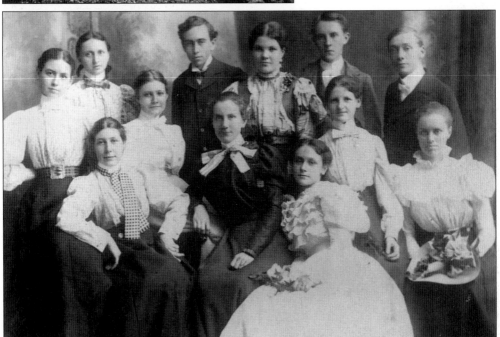

The Civil War forced Marshall to close for several years. In 1867, the West Virginia Legislature designated it as a state normal school for the training of teachers. However, it wasn't until the tenure of President Lawrence J. Corbly, 1896–1915, that the school began to grow. Shown here are the members of the graduating class of June 1898.

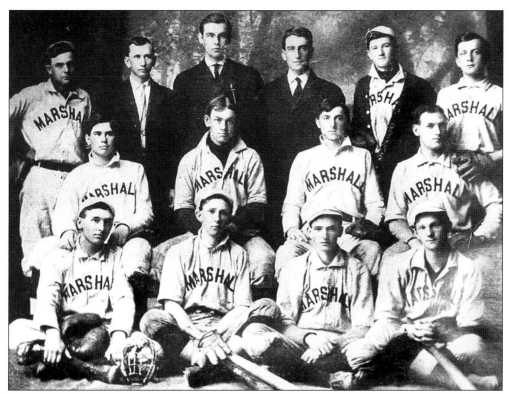

This Marshall College baseball team played for the school around 1900.

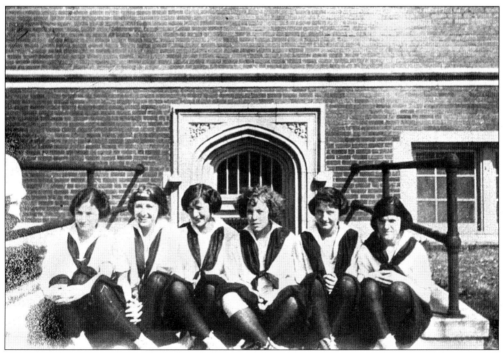

Shown here are the members of Marshall's 1923 women's basketball team, the school's first.

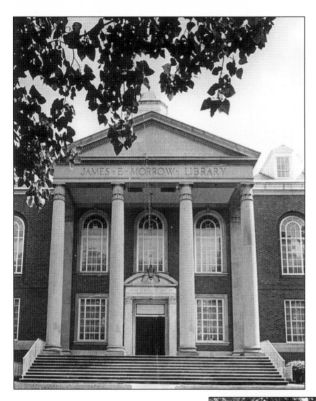

Marshall's James E. Morrow Library, dedicated in 1931, was named for a Marshall College principal, serving 1872–1873. The principal's son Dwight W. Morrow contributed $25,000 toward its construction. This view shows the front, or Third Avenue, view of the library. A major wrap-around addition was constructed on the building's back and both sides in the 1960s.

The first building to be constructed as a separate unit from the Old Main complex was Northcott Hall, Marshall's original science building. Classes first started using the building in 1916. When Marshall built its new Science Hall in 1950, other classes were shifted to Northcott. It was recently demolished to make way for construction of the school's new John Deaver Drinko Library.

Seven

THE '37 FLOOD

There had been Ohio River floods before and there would be other floods afterwards, but the 1937 Flood is the one that still has folks in Huntington talking. Those who went through it would later recall their experiences in much the same way that younger people remember where they were when President Kennedy was killed.

The first Ohio River flood recorded after the first white settlers came to the Ohio Valley was in 1763; others of varying size followed at irregular intervals. In 1820, famed artist and naturalist John James Audubon wrote, "When it happens that, during a severe winter, the Allegheny Mountains have been covered with snow to the depth of several feet, and the accumulated mass has remained unmelted for a length of time, the materials of a flood are thus prepared . . . On such occasions, the Ohio . . . presents a splendid, and at the same time appalling, spectacle."

In 1884, the Ohio again flooded and this time washed an estimated 2,000 homes downstream. People in the new town of Huntington watched with horror as the angry waters swept away their homes and businesses. But soon the flood receded, the mud was scraped away, and the community went about its business.

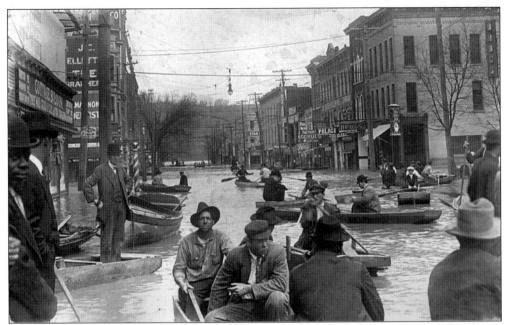

In March of 1913, the Ohio again flooded and again Huntington found itself hard hit. Hundreds of people were driven from their homes by the high water and forced to flee to higher ground. Shown here is a view of the flooded intersection at Ninth Street and Fourth Avenue, crowded with rowboats.

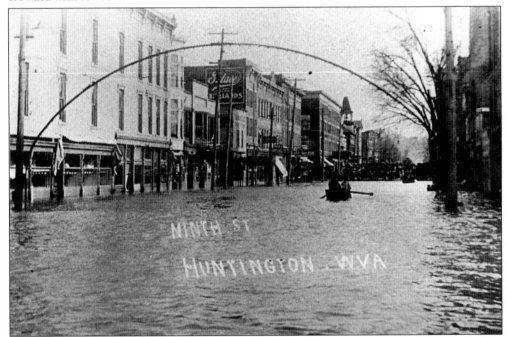

Here's another 1913 view of a flooded Ninth Street, this time looking south from Third Avenue. The bell tower at just right of center in the photo is Huntington's first City Hall. The arch extending over the flooded street was part of an early system of electric lights used to illuminate the streets at night.

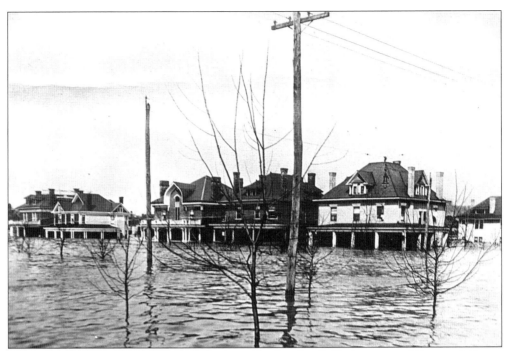

The 1913 flood inundated this residential neighborhood at Fifth Avenue and Sixteenth Street (now Hal Greer Boulevard). The April 13, 1913 edition of *The Herald-Dispatch* reported that during the flood three babies were born at the refugee center at Oley School, only three blocks from where this photo was taken.

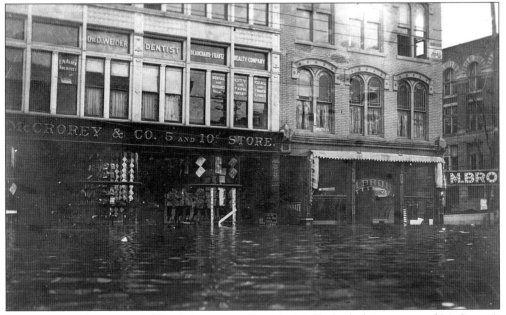

Businesses on Huntington's Third Avenue, such as the M. Broh clothing store and McCrorey's 5 and 10¢ store, located on the southeast corner of Third Avenue and Ninth Street, were heavily damaged by the 1913 flood. Other businesses simply adapted to the emergency. When the saloons were closed by city edict, bootleggers did a busy trade by boat.

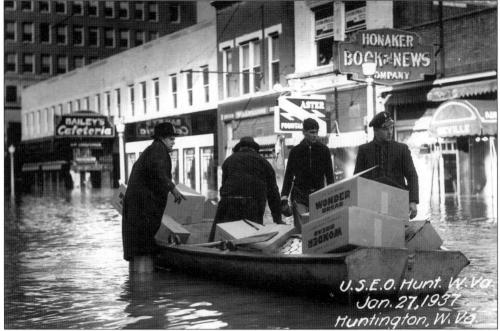

Again the scene is a flooded Ninth Street in downtown Huntington, but this time it's January of 1937. The famous 1937 flood on the Ohio, the worst ever, flooded communities the whole length of the river and claimed 250 lives. In this photo, volunteers can be seen with a rowboat filled with emergency food. In the background are two familiar Huntington businesses of the day, Bailey's Cafeteria and Honaker Book and News Company.

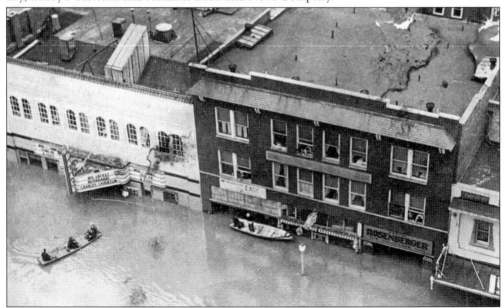

This unusual view looks down on a flooded Fourth Avenue between Tenth and Eleventh Streets. At left, sticking out over the water is the marquee of the Palace Theater (today renamed the Camelot). The letters on the theater's marquee indicate the feature playing was *His Latest Rembrandt*, starring Charles Laughton.

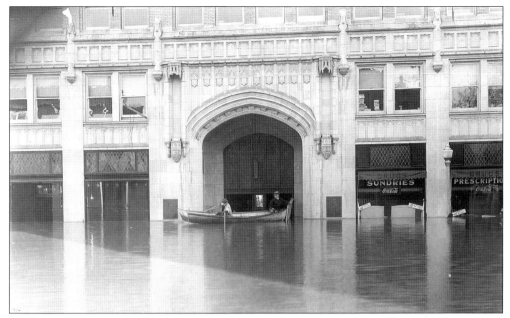

Shadows play across the floodwaters on Eleventh Street between Fourth and Fifth Avenues. The handsome building in the background is the Coal Exchange Building. The "Sundries" and "Prescriptions" signs in the windows at the right of the photo mark the presence of Kaiser's Drugs, long located at the corner of Fourth Avenue and Eleventh Street.

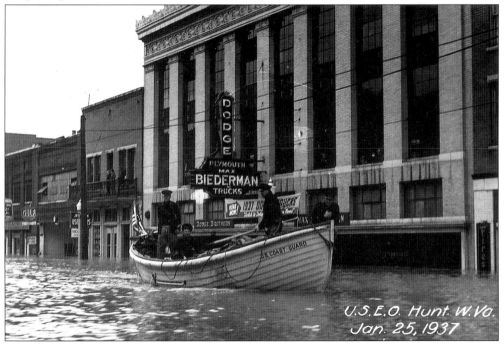

A U.S. Coast Guard boat makes its way along Fourth Avenue at Seventh Street. Behind the boat a large sign identifies the Max Biederman Dodge-Plymouth dealership. In the years immediately before and after World War II, this stretch of Fourth Avenue was known as "Auto Row" because it was home to so many auto dealers.

89

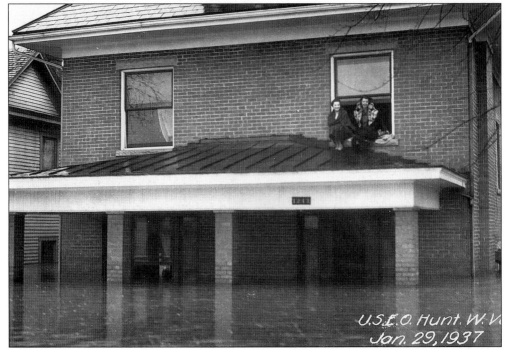

Although they're bundled up against this cold, these smiling young women perched on a second-floor windowsill at a house on Huntington's Washington Avenue near West Twelfth Street don't seem especially concerned about their plight. At the flood's peak, 6,000 Huntington residents were homeless, and emergency workers were struggling to feed as many as 9,000 people a day.

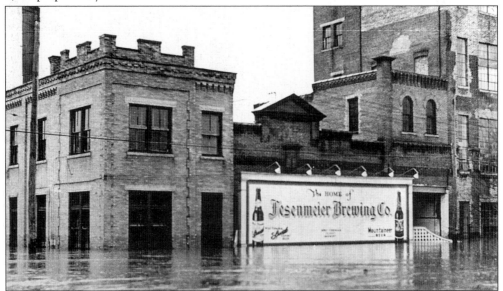

A January 28, 1937 photo shows the floodwaters lapping around the Fesenmeier Brewing Company on the southwest corner of Madison Avenue and West Fourteenth Street in the former Central City. The old brewery dated back to 1891 and was once West Virginia's largest. It ceased operation in 1971 and the next year was leveled to make way for a shopping center.

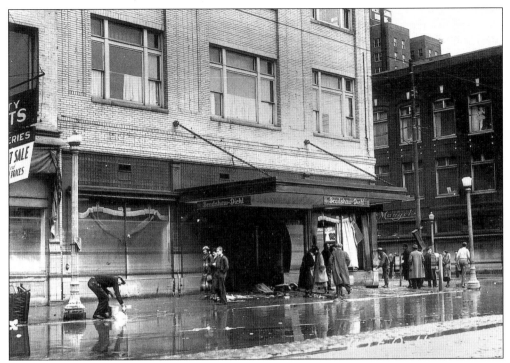

When the 1937 floodwaters receded, five Huntington residents were dead and the city was a soggy ruin. Here, curiosity seekers survey the damage to the Bradshaw Diehl Company, then one of the city's leading department stores. Today its site at the corner of Third Avenue and Tenth Street is occupied by the Radisson Hotel Huntington.

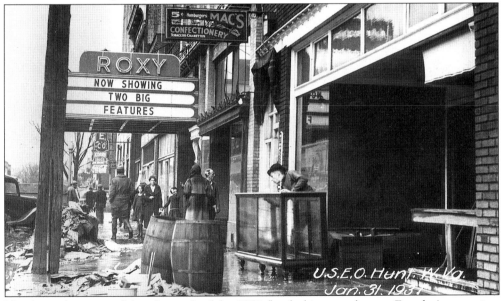

Here's another view of the aftermath of the 1937 flood, this one taken on Fourth Avenue, just west of Eleventh Street. A worker in front of an unidentified store cleans an empty showcase. The Roxy Theater, here advertising "Two Big Features," is one of several that have vanished from downtown Huntington over the years.

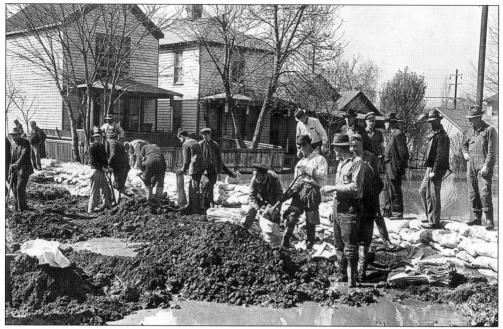

Huntington was still struggling with the millions of dollars in damage inflicted by the 1937 flood when, in June of 1940, the Ohio River again threatened to flood. Here, workers at an unidentified Huntington location are constructing a sandbag levee. The flooding of 1940 proved minor compared with that of 1937, referred to as "the granddaddy of all floods."

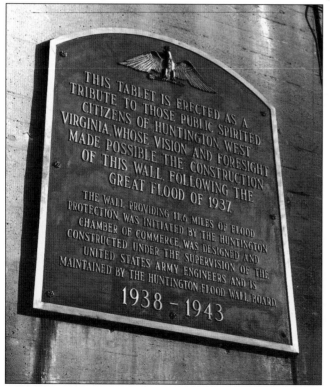

THIS TABLET IS ERECTED AS A TRIBUTE TO THOSE PUBLIC SPIRITED CITIZENS OF HUNTINGTON, WEST VIRGINIA, WHOSE VISION AND FORESIGHT MADE POSSIBLE THE CONSTRUCTION OF THIS WALL, FOLLOWING THE GREAT FLOOD OF 1937.

THE WALL, PROVIDING 11.6 MILES OF FLOOD PROTECTION, WAS INITIATED BY THE HUNTINGTON CHAMBER OF COMMERCE, WAS DESIGNED AND CONSTRUCTED UNDER THE SUPERVISION OF THE UNITED STATES ARMY ENGINEERS AND IS MAINTAINED BY THE HUNTINGTON FLOOD WALL BOARD.

1938 - 1943

This plaque, placed on the completed wall in 1943, tells the story of the Huntington floodwall, erected in the wake of the 1937 flood. Had the wall not been a U.S. Army Corps of Engineers project, its completion might have been indefinitely delayed, since concrete and steel became scarce items when World War II broke out.

Eight

AROUND THE COUNTY

Although Cabell County's population has remained about the same in recent years, the 2000 Census showed that many of the county's smaller communities and unincorporated areas had increased—at the expense of Huntington.

Barboursville's population increased by 14.7 percent, from 2,774 in 1990 to 3,183 in 2000. Meanwhile, Huntington's population decreased by 6.1 percent, from 54,844 in 1990 to 51,475. Significantly, this trend reverses the history which saw, in the 1870s and 1880s, the brand-new town of Huntington quickly eclipse Barboursville in size and eventually wrest the county seat from the older community.

The most obvious factor in that trend is the Huntington Mall, which is located, despite its name, in Barboursville. Since it opened 20 years ago, the mall not only has supplanted downtown Huntington as the center of regional shopping but also has sparked an incredible amount of development in the area surrounding it. Changes in housing tastes also have played an important role. Many of today's homebuyers want new houses with large lots, the kind of homes almost impossible to find in the city proper. Whatever the reasons, there's no disputing that the eastern end of Cabell County—beyond the Huntington city limits—is the county's fastest growing part.

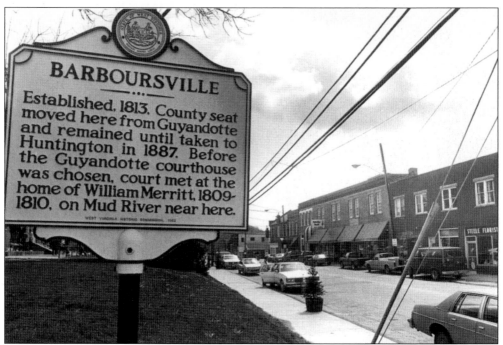

Originally chartered in 1813 and named for Virginia governor James Barbour (1812–1814), Barboursville later was incorporated by an act of the West Virginia Legislature on February 12, 1867. In its early years, the village not only was a retail center but had small factories that produced furniture, hats, wagons, and buggies, as well as a sawmill, tanner, and harness maker.

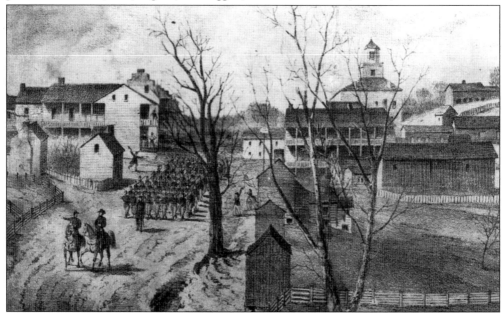

During the Civil War, Barboursville was the scene of at least two skirmishes. Shown here, in a sketch done by an unknown artist in November of 1861, is the entrance into the town of a unit of the Union Army—the 34th Regiment of the Ohio Volunteers. The building with the cupola at left of center was then the Cabell County Courthouse.

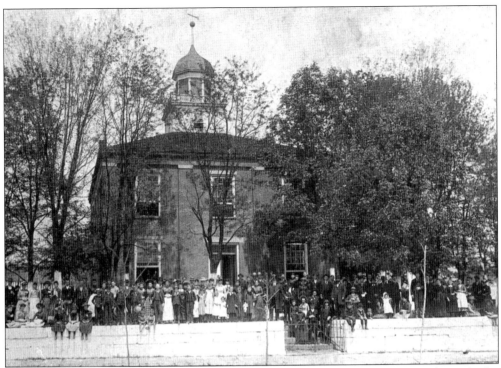

Confederate raids eventually made it necessary to move the county seat to Guyandotte. At the war's end, it was moved back to Barboursville, but in 1887, with Huntington now the center of business activity in the county, it was moved to Huntington. At that point, the former courthouse became home to, briefly, the Barboursville Seminary and then, when that venture failed, Barboursville College.

Renamed Morris Harvey College in 1901, the former Barboursville Seminary had grown considerably in size by 1908 when this postcard photograph was made. In 1935, Morris Harvey, hard hit by the Great Depression, decided it couldn't compete with nearby Marshall and so moved to Charleston, where it evolved into today's University of Charleston.

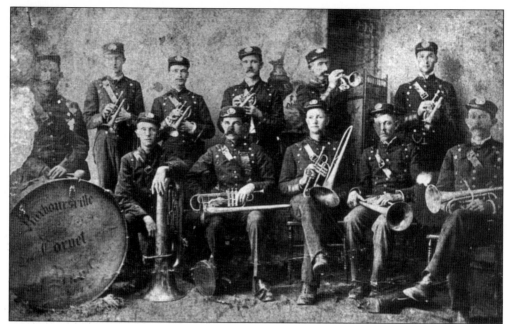

In his *Cabell County Annals and Families*, George Selden Wallace noted that in 1869 the village of Barboursville "boasted of a brass band which was given permission to use the courthouse for practice." Shown here in an old photo dated 1888, is the Barboursville Cornet Band, perhaps a successor to the 1869 musical group.

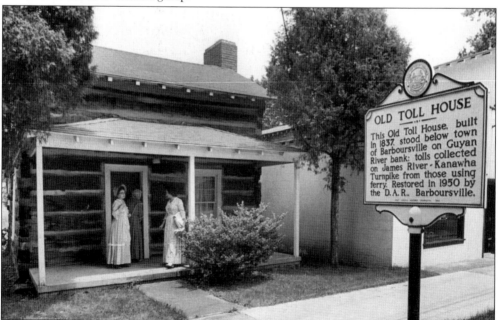

When the James River and Kanawha River Turnpike was the only road westward over the mountains from Virginia, tolls were collected at rude log cabins such as this one. Most have long since vanished, proving to be victims of time and neglect. This example doubtless would have suffered a similar fate if the Barboursville Chapter of the Daughters of the American Revolution had not purchased it, moved it from its original site, and restored it.

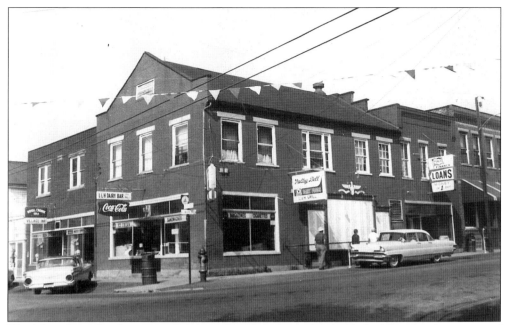

The Thornburg family operated a store for 75 years in this brick building on the corner of Barboursville's Central Avenue and Main Street. When this photograph was shot in the 1940s, the old building, which was once used as a stagecoach stop, was home to the L & H Dairy Bar.

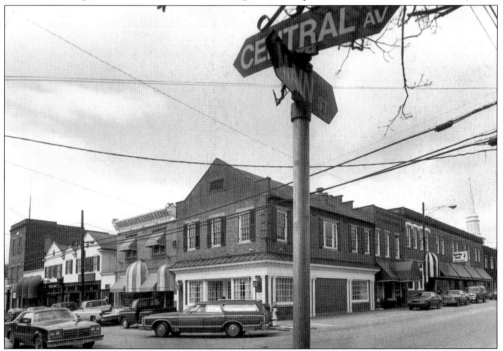

Flash forward another 40 years or so and here's another photograph of the Thornburg building, this one taken in 1985. In the intervening years, the old building has undergone some remodeling and clearly is ready for many more years of service. Today, it's home to a stockbroker's office.

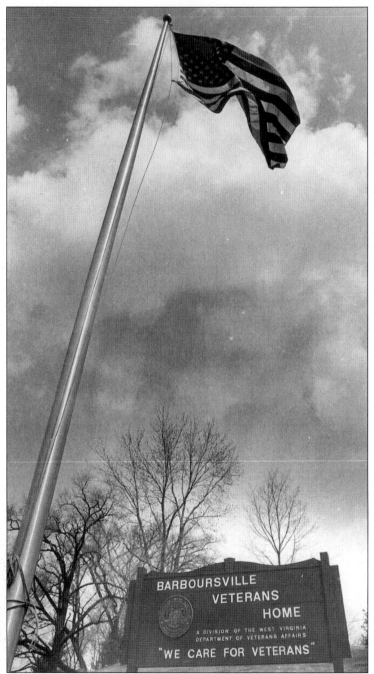

In recent years, a trend of not institutionalizing the mentally ill has resulted in sharp declines in the number of mental patients who are hospitalized. In the 1970s that trend prompted the closing of the Barboursville State Hospital. In 1981, after a long campaign by the state's veterans' organizations, the vacant complex was put to a welcome new use as the West Virginia Veterans Home. Dedicated November 8, 1981, the Barboursville facility is the only one of its kind in the state. The home is a "domiciliary" type facility that provides a non-institutional community setting for veterans, especially those who have no other home.

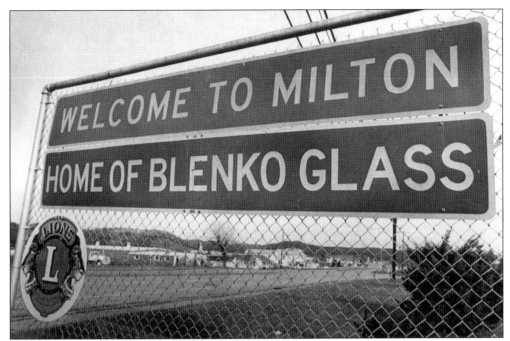

Incorporated in 1876, Milton had its beginnings as a way station on the then-new Chesapeake & Ohio Railway. It was named for Milton Reece, the largest landholder in the vicinity at the time. Local residents sometimes describe themselves as being from "Milton on the Mud," a reference to the usually tame Mud River that sometimes spills out of its banks and sends folks heading for higher ground.

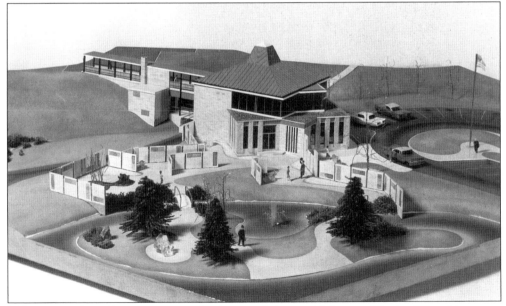

Milton is perhaps best known as the home of the world-famous Blenko Glass Company, manufacturers of widely collected glassware, stained glass used for church windows, and fine leaded glass used in historic restorations. Shown here is an architect's scale model of a visitors' center and gift shop the company built at its factory in 1966.

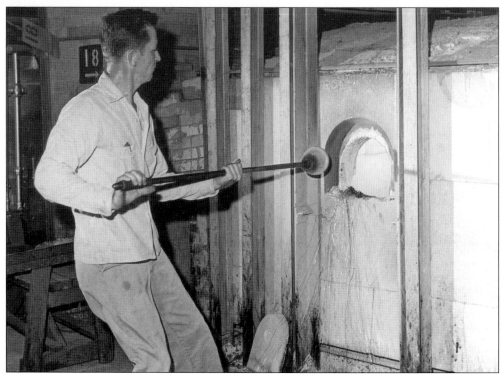

Blenko Glass was founded in 1923 by an Englishman, William Blenko, who had operated a glass plant in England and came to this country in 1923 with the express purpose of starting up a glass operation. He was attracted to Milton by the abundance of natural gas as a cheap fuel to fire the furnaces, such as the one above, that are used in making glass.

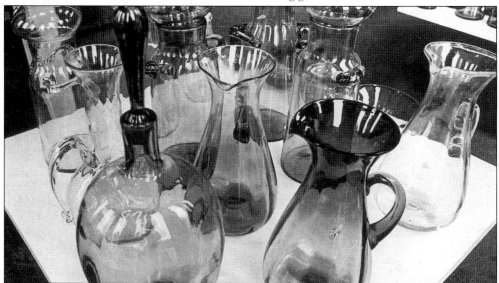

Originally the company made only sheet glass, but with the coming of the Great Depression and the resultant lessening of demand for new or replacement glass, Blenko began making the colorful handblown vases, pitchers, and other glassware for which it has become internationally known. The company remains a family-owned enterprise.

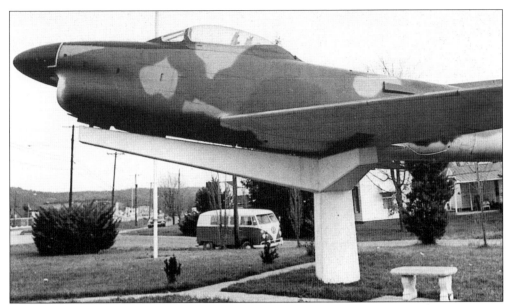

Poised as if in flight, a jet fighter casts its shadow on U.S. 60 near the Milton business district. Although there is no marker on the seven-foot pedestal that supports the Air Force F-86D Sabre jet, anyone in Milton can tell you it is a memorial to those from Milton who were killed while serving their country. Dedicated in 1962, the plane was put in its place of honor by Milton American Legion Post 139.

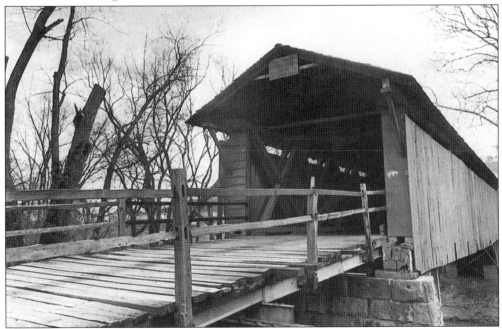

Said to have been built in 1876, this covered bridge at Milton, shown here in an undated old photograph, is one of the county's best-known landmarks. Badly deteriorated, the bridge was closed to traffic years ago and in 1997 was removed from its long-time location lest it collapse into the Mud River. Now it has been moved to a new location on the grounds of the West Virginia Pumpkin Festival.

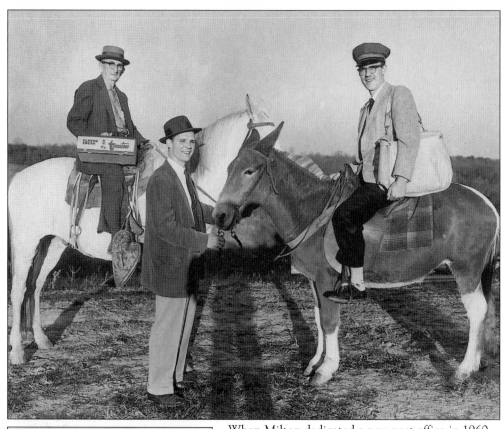

When Milton dedicated a new post office in 1960, among those celebrating was, at left, 83-year-old C.C. Carroll, who delivered the mail by horseback from 1905 to 1919. He recalled being paid $40 a month, with the provision that he supply and feed his own horse. At right, on the mule, is Milton mail carrier Donald Jordan. Standing is Acting Postmaster Erva Cooper.

Culloden, located on U.S. 60 near the Putnam County line, dates back to a tavern that opened in 1818 and was burned by Union troops in the Civil War. In the 1890s, when Capt. B.H. Justice wanted to open a saloon and the county refused to issue him a license, he got around that by having the town incorporated. Interest in the municipal corporation lapsed, however, and Culloden reverted to being unincorporated.

Albert Gallatin Jenkins graduated from Harvard Law School in 1850 and practiced law for a short time in Charleston before returning to the family home at Greenbottom in Cabell County. He served two terms in the U.S. Congress but with the coming of the Civil War, donned Confederate gray and became one of the South's finest generals. He was mortally wounded at Cloyd's Mountain in 1864 and is buried in Huntington's Spring Hill Cemetery.

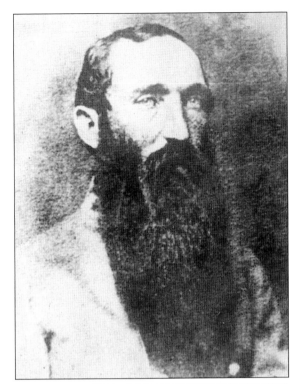

Although generally referred to as the "General Jenkins House," this handsome brick home that fronts on the Ohio River just north of Huntington was built by the general's father in 1835. The house has a stone foundation and the bricks were made on the grounds. The timbers are hand-hewn and put together with wooden pegs. In recent years, the house has been restored and now is open to the public on a limited basis.

A handwritten note indicates this photograph was made at the Toney Hill School on Glenwood Road just outside of Milton in 1913. However, it could have been any of the many one-room schools that once dotted the county, all of them long since closed. Behind the young scholars and their serious-looking teacher are displayed an American flag and a West Virginia state flag. By chance, the American flag is displayed upside down

Salt Rock, located on West Virginia 10 near the Lincoln County line, is named for the large quantities of salt once found in the area. Local legend says the little community's first settlers were chasing Indians who had stolen their horses. Once the pursuers arrived in the area, they liked it so much they stayed. The legend doesn't tell whether they got their horses back. Today's Salt Rock residents generally commute to jobs in Huntington.

Nine

THEN AND NOW

Sometimes, when everything is going just right for us, we think how nice it would be to preserve things just as they are. It's only a fantasy, of course. Nothing stops the ticking clock. Change is a certainty. Sometimes it's a change for the better, sometimes not.

Change is the theme in this section, as we look at scenes from the past and the present. Here are yesterday's high schools and their new, high-tech successors. Here is the familiar old Carnegie library that so many local readers fondly remember and today's modern Cabell County Public Library.

Here, pictured side by side, is the horror of the Marshall University plane crash of 1970 and today's memorial to the crash victims. Here is old Fairfield Stadium and the new Marshall Stadium that has been the backdrop for the Herd's remarkable rise to national football prominence. Here is the Ohio Valley Bus Company's fleet from yesteryear and the buses operated today by The Transit Authority. Here is yesterday's old hospitals and their modern counterparts that have made the community a regional center for medical care. And here is a look at a landmark building, once home to a vanished department store and today the scene of a new restaurant that's helping breathe new life into downtown Huntington.

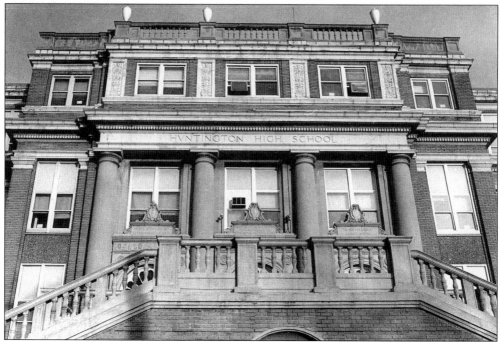

With the new century that arrived in 1901, the growing community of Huntington needed a new high school. The result was this handsome building, which welcomed its first students on September 4, 1916. When the new Huntington High was opened in 1996, the old building stood vacant for some time but since has been renovated as Huntington High Renaissance Center, a multi-use facility that includes senior-citizen housing, an arts group, and a branch of the Huntington YMCA.

When Milton High School was built in 1928, its original name was Grant District High. The structure served thousands of Milton students prior to the 1994 consolidation of Milton and Barboursville High into the new Cabell Midland High. (See page 108.) The old building was demolished after the opening of Cabell Midland, but its cornerstone was saved and placed on display in April Dawn Park.

This photograph of Huntington East High School was taken just about the time it opened in 1940. Prior to this school's completion, students at a badly overcrowded Huntington High were attending in shifts, with half the student body going to classes in the morning and the other half going in the afternoon. With the 1996 consolidation of Huntington High and Huntington East, the Cabell County Board of Education moved its offices to the former Huntington East.

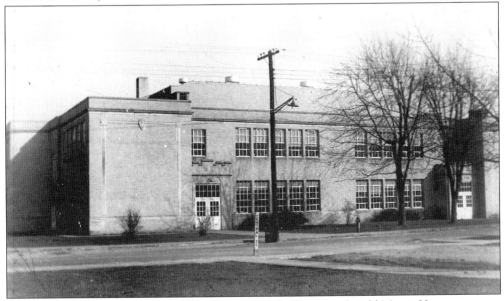

The first Barboursville High School students used a building on the old Morris Harvey campus. In 1928, the cornerstone was laid for the central section of this building, which, with a number of additions constructed over the years, housed Barboursville High School until its 1994 consolidation with Milton at Cabell Midland.

Despite the predictions of the naysayers, Cabell County voters went to the polls and approved a bond issue to build two new "world-class" high schools to replace the four that had served students for so many decades. The first of the two, Cabell Midland, cost more than $25 million and opened in 1994 to rave reviews from students, faculty, and parents.

In a mostly applauded compromise, the county's second new high school, which merged the Huntington High and Huntington East student bodies, preserved the Huntington High name but adopted the Huntington East nickname, the Highlanders. Built on a hilltop on West Virginia 10 just outside the Huntington city limits, the $27-million school opened in 1996.

This 1959 photograph should bring back lots of memories for many folks. It's the checkout desk at the old Carnegie building of the Cabell County Public Library at Fifth Avenue and Ninth Street. The stairway behind the desk goes up to the second floor reference department. The children's department was housed in the building's basement. Today, the old building houses a business school, Huntington Junior College.

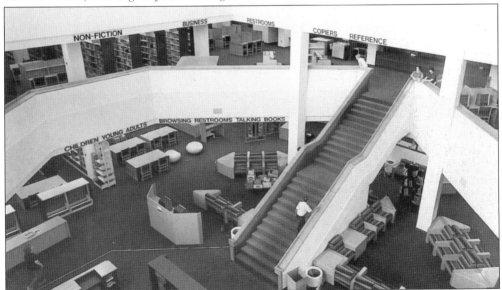

In 1980, the old Cabell County Library became history, as the library moved into handsome new quarters located just across Ninth Street from its original building. A human chain of volunteers helped move tens of thousands of books to this modern, spacious building. The atrium in the new library looks almost big enough to swallow the Carnegie building.

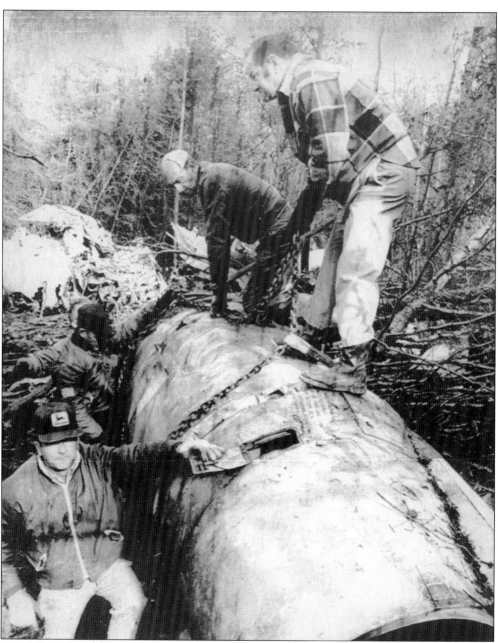

Officials examine the wreckage of the chartered jetliner that crashed at Tri-State Airport on November 14, 1970, killing all 75 aboard—members of the Marshall football team, coaches, the aircraft's crew, and a number of local leading citizens who had traveled with the team to a game in Greenville, North Carolina. Marshall and the community were plunged into mourning and would be a long time recovering. Even today, the emotional wounds from the crash remain. Some scars never heal.

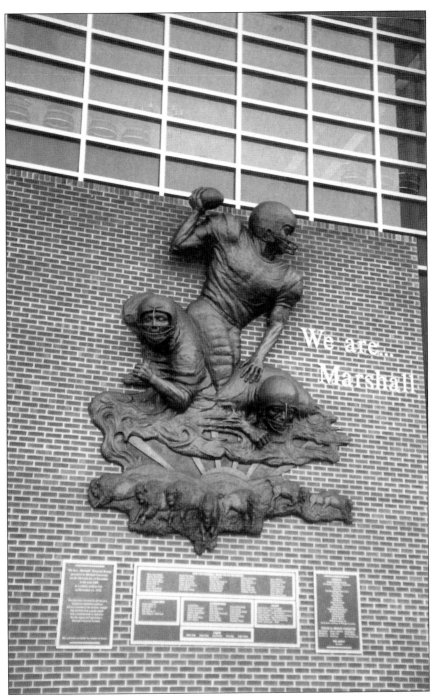

A memorial service held each year guarantees that the victims of the 1970 crash will never be forgotten by the campus or community. Marshall's Memorial Student Center stands as a tribute to them, Twentieth Street has been officially renamed Marshall Memorial Boulevard in their memory, and on the west wall at Marshall Stadium is this impressive 17-by-23-foot bronze sculpture. Designed by artist Burl Jones, the bronze cost $150,000, all of which was raised by Marshall fans.

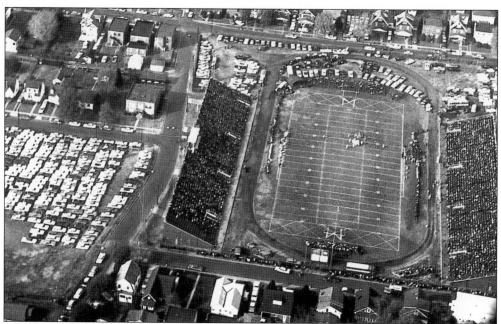

The site on Huntington's South Side had been a garbage dump before Fairfield Stadium was built in 1928. The red brick stadium served well for years and in this shot from the air actually looks pretty impressive. But over the years Fairfield deteriorated badly and was actually condemned by the city building inspector in 1963. Only major repairs and renovations enabled continued use of the old stadium. For years, Marshall football fans longed for a new, larger stadium.

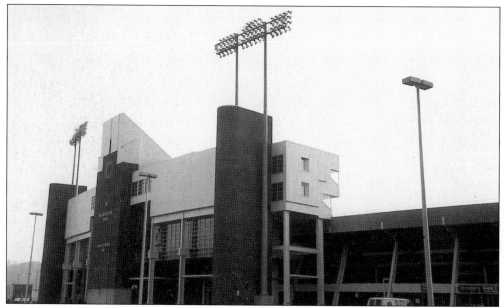

Marshall finally realized a decades-old dream in 1991 when it opened its new $30-million football stadium. With 28,000 seats, the stadium attracted a standing-room only crowd of 33,116 fans for the September 7 opener, which saw the Thundering Herd edge the University of New Hampshire 24–23.

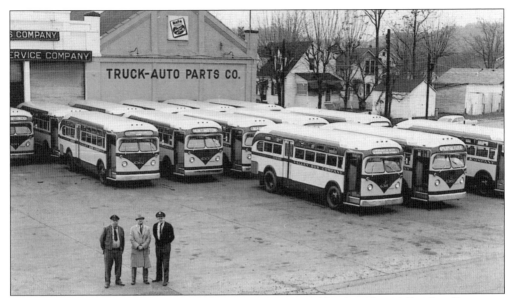

This 1953 photo shows a portion of the fleet then operated by the Ohio Valley Bus Company. In the 1950s, the company operated 80 buses on more than dozen routes in the area. It employed 235 people, including 145 drivers, but the public's steadily growing love affair with the automobile was pinching private bus companies nationwide. Eventually, the declining number of riders and a 1971 strike by its employees brought Ohio Valley Bus to the end of the line.

As the 1971 Ohio Valley Bus strike dragged on, local officials put together a $3.2-million package to buy out the company and put its buses back on the road. Thus, the Tri-State Transit Authority, now The Transit Authority, was born and began operation on July 17, 1972. Today, TTA operates 29 buses, 10 Dial-A-Ride vans, and two replica streetcars. The system is supported by a combination of farebox revenues, federal grants, and a local tax levy that is regularly renewed by city and county voters.

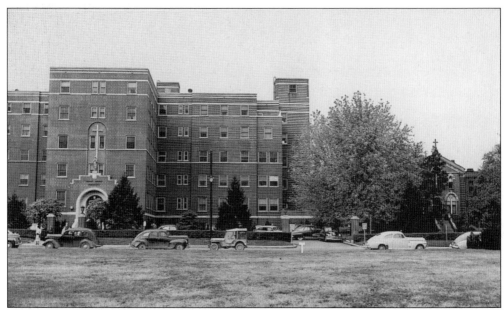

St. Mary's Hospital first opened its doors in Huntington on November 6, 1924, as the result of the hard work and prayers of the Pallottine Missionary Sisters. In the beginning, St. Mary's consisted of 35 beds located in an old prep school that had been converted to a makeshift hospital. In 1930, a 110-bed addition was built and a 1937 fund-raising drive financed construction of the first five-story addition to the hospital.

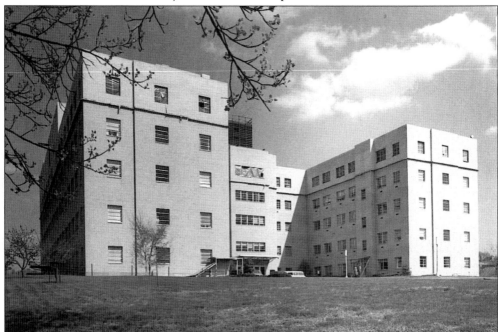

Planning for what was to become Cabell Huntington Hospital began in 1945 and led to a $3-million bond issue, approved by an impressive 88 percent of the voters in 1952. The hospital opened in 1956 and has grown steadily in the nearly half-century since. This view dates from 1963 and clearly shows the H-shape of the original hospital.

Today, St. Mary's Hospital is Cabell County's largest private employer and, with more than 300 staff physicians representing a broad range of specialties, is able to provide a broad range of medical services including open-heart surgery, cancer treatment, women's health services, emergency/trauma services, and psychiatric care.

Today, Cabell Huntington has intensive care units for pediatric patients and burn victims, a hemodialysis unit, and HealthNet III aeromedical transport. It is also home to the $31.9-million Marshall Medical Center. Opened in 1998, the center brought together elements of the Marshall School of Medicine that have been scattered in more than a dozen buildings throughout Huntington.

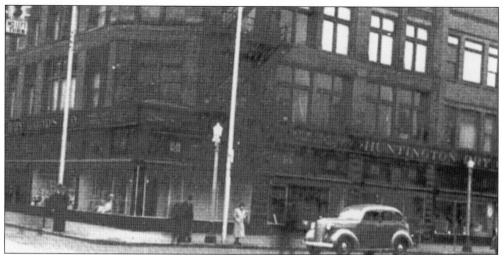

On June 7, 1923, Huntington mayor Floyd Chapman turned a ceremonial key to open the doors of Huntington Dry Goods Company at Third Avenue and Ninth Street, long one of Huntington's leading downtown stores. In 1955, the store changed its name to The Huntington Store, reflecting that it had expanded far beyond selling just dry goods. However, the store closed in 1982, with management admitting that the venerable retailer could not compete with the newly opened Huntington Mall.

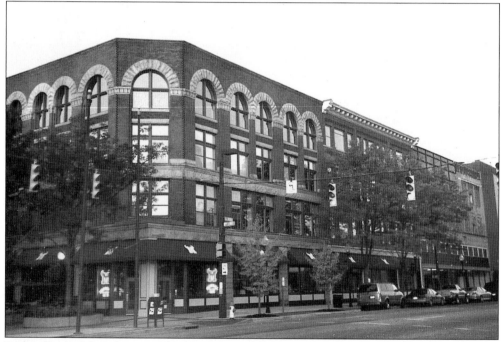

Today, the building that was The Huntington Store houses the Marshall Hall of Fame Café, a colorful new restaurant with a Marshall sports theme. Jon Self, president of Half of Fame Development Company, and his partners opened the highly successful Buckeye Hall of Fame Café in Columbus, where Ohio State University athletics provided the theme. When they decided to build similar restaurants in other communities, they selected Huntington as a good place to start that expansion effort.

Ten
FAMILIAR FACES

Here they are, some of the faces we remember. Some represent the world of politics—they are presidents, governors, and local politicians. Some are educators or members of the media. The world of sports is represented and so are the performing arts. One familiar face is that of a legendary fire chief and another is that of a man who came into thousands of homes via television every Saturday night for nearly 20 years.

This final chapter could run on and on and ultimately fill far more pages than are in this entire volume. Far from comprehensive, the small selection of faces here—some of them instantly recognizable, a few perhaps a bit less so—is simply intended to remind us of how much we owe to those who have gone before.

Ultimately, a community like Huntington and a county such as Cabell are more than such-and-such number of square miles of real estate; more than streets and highways; more than business, industries, and homes, large and small; more than the kind of statistics found in a Census report, and more than the dusty history that's found in books. Communities and counties are people. And, with that in mind, here are just a few of the people who have helped make Huntington and Cabell County a wonderful place to live, work, and play.

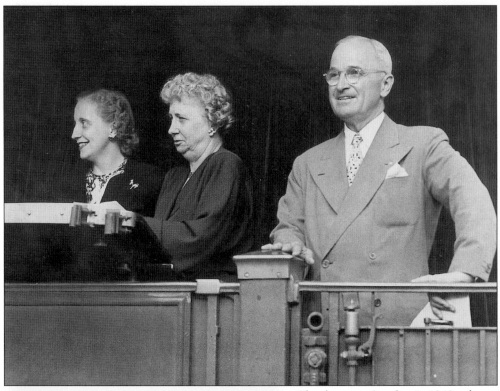

The date was October 1, 1948, when President Harry Truman, whistle-stopping across the county in a hard-fought reelection campaign, stopped in Huntington. Truman, accompanied by his daughter Margaret and his wife, Bess, used most of his 13-minute visit to lambaste the "Do-Nothing Republicans" in Congress. In the November vote, he proved the political experts wrong and swept to victory.

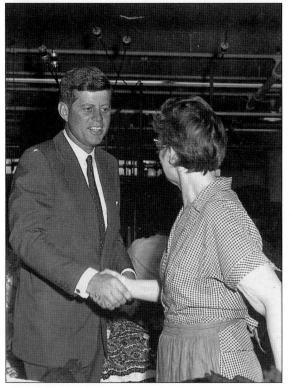

Massachusetts Senator John F. Kennedy shakes hands with a worker at a Huntington dress factory as he campaigns for the Democratic presidential nomination in the historic 1960 West Virginia primary. Kennedy beat Hubert Humphrey in the West Virginia voting, a victory that put him on the road to the White House.

Born in Pennsylvania in 1863, Col. J.H. Long was the dean of West Virginia newspapermen for more than half a century. Long purchased the *Huntington Advertiser* (an afternoon newspaper) in 1885 and later presided over the company that published it, *The Herald-Advertiser* (a morning paper) and *The Herald-Dispatch* (a combined Sunday edition). He is shown here on his 92nd birthday in 1955. He died in 1958.

On hand for the 1928 opening of Fairfield Stadium were these dapper dudes. From left to right are Fred Burns, sports editor of *The Herald-Dispatch* until his retirement in 1967; Douglas L. (Dug) Freutel, who held various jobs with the *Advertiser* from 1919 to 1944; Raymond Brewster, who started in *The Herald-Dispatch* mail room in 1920 and was editor-in-chief when he died in 1972; and William T. Bess, sports editor for the *Advertiser* and later promotion manager for the Huntington newspapers, who retired in 1967.

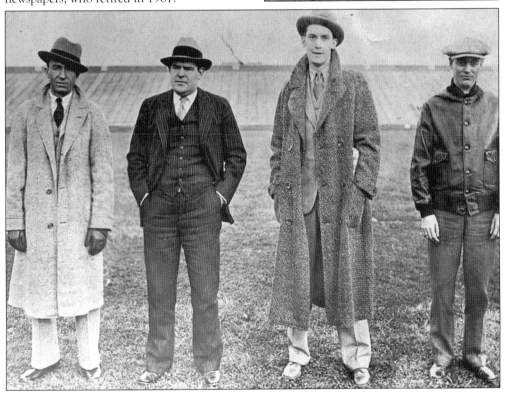

Huntington's Dr. Henry D. Hatfield liked to describe himself as a "country doctor." And he was. But he was more, much more than that. He served as governor of West Virginia (1913–9117), was a member of the U.S. Senate (1928–1934), and achieved national recognition as a surgeon. His was a crowded, busy lifetime, which saw him still treating patients until a few years before his death at age 87 in 1962.

One of Huntington's most colorful mayors ever, Walter W. Payne served from 1940 to 1952. Payne loved to get out of the office and move around town. Here he's seen looking on as a machine operator punches out parts at Huntington's ACF Industries plant. Payne frequently donned a fireman's coat and hat and chased the fire trucks to the scene of a blaze.

In 1957, the city of Huntington switched from a strong mayor form of government to a city manager form. The first city manager under the new system of government was Robert M. Hoisington, who served until 1963. He is shown here in an on-camera interview with Arthur J. Smith, who was then news director at WHTN (now WOWK), Channel 13.

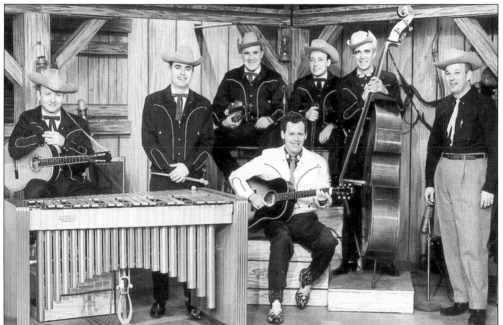

At far right in the photo above is Dean Sturm, the down-home emcee of WSAZ, Channel 3's *Saturday Night Jamboree*, perhaps the most popular television program in Tri-State history. The country music show debuted in 1953 and was a Saturday night tradition in many homes for nearly 20 years. Leaving WSAZ, Sturm became senior producer/director of closed circuit television at Marshall and served four years on Huntington City Council. He died in 1987.

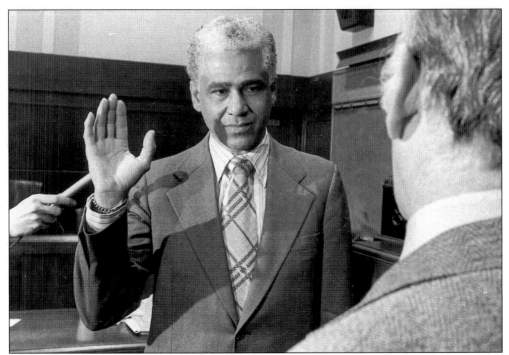

In 1977, Joseph Slash took the oath of office as Cabell County school superintendent, becoming the first African-American school superintendent in West Virginia. Slash died in 1986 after suffering a heart attack while at a Marshall University football game at old Fairfield Stadium. He was 67.

John W. Gallagher, at right, joined the Huntington Fire Department in 1934 and rose through the ranks to become chief in 1954, a post he held until he retired in 1969. Under his leadership, the department became one of the best small fire departments in the country and the city's first insurance rating improved from Class 7 to Class 2. Gallagher, who died in 1974, is shown here at the Tri-State Fire School, which he founded.

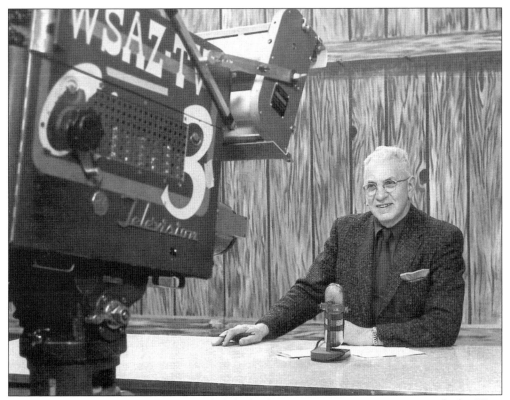

A Kentuckian by birth, William D. Click had a long career as a county agent with the West Virginia University Extension Service, including 22 years as Cabell County agent. In World War II, "Farmer Bill," as he was known to thousands, started writing a newspaper column in *The Herald-Dispatch*, encouraging families to plant "Victory Gardens." At war's end, he continued his column and with the advent of television was soon in front of the camera. He died in 1960.

The daughter and granddaughter of slaves, Memphis Tennessee Garrison lived most of her life in the coalfields in Gary, West Virginia. The veteran schoolteacher, who "retired" to Huntington in the 1950s, became a national vice president of the NAACP. A political activist and a newspaper columnist, she was someone who never quit helping others. She is shown here accepting an honorary doctorate from Marshall University in 1970. She died in 1988.

In her 16 years as its director (1971–1987), Roberta Shinn Emerson was the driving force behind transforming the Huntington Galleries into the Huntington Museum of Art, a transition that meant far more than a change in name. Under her leadership, the museum grew from a staff of 5 and a $125,000 annual budget to a staff of 30 and a budget of more than $1 million.

Herman P. Dean, who died in 1978 at the age of 80, was the owner of the former Standard Printing and Publishing Company, the publisher of the weekly *Wayne County News*. A Sunday school teacher and a world traveler, he also lived two years with the Eskimos. He loved hunting, fishing, and collecting guns. Today, the Herman P. Dean Firearms Collection is one of the most popular permanent exhibits at the Huntington Museum of Art.

Talented Revella Hughes began playing the piano at age 5 and in her 20s starred on Broadway in the George White musical *Runnin' Wild*. From 1932 to 1942, she lived in her native Huntington, caring for her ailing mother and teaching in the then-segregated local schools. But after her mother's death she returned to the entertainment scene, touring the world. Though "retired," she continued to give occasional concerts until shortly before her death in 1987 at age 92.

When he was 11 years old, Carl Hoffman began running errands for a druggist in his native Ironton, Ohio—his first exposure to the world of medicine and an experience that convinced him he wanted to be a doctor. In a medical career of more than 40 years, the Huntington physician became a nationally known urologist and was elected president (1972–1973) of the American Medical Association. He died in 1981 at age 77.

Blind in one eye and with sharply limited sight in the other, W. Page Pitt refused to let that slow him down. When he joined the Marshall faculty in 1926, his responsibilities included a single journalism class with five students. From that humble beginning, Pitt built the program into one nationally recognized for the quality of its graduates. When he retired in 1971, Marshall's School of Journalism and Mass Communications was named in his honor.

Cam Henderson, surely the best-known coach in Marshall sports history, was part of the athletic scene at the school for 20 years, from 1935 to 1955. In his early years, he coached both football and basketball but later he coached only basketball. He died in 1956. Marshall's Henderson Center, opened in 1981, was named in his honor.

Marshall president Stewart H. Smith (1946–1968) successfully steered the school to the longtime dream of university status. Smith campaigned for the cause tirelessly, buttonholing politicians and anyone else he thought might be of assistance. His efforts were rewarded on March 1, 1961, when the legislature voted its approval of the necessary bill.

Jules Rivlin made his mark as both a basketball player and coach at Marshall. A native of Washington, Pennsylvania, he played three years for Cam Henderson, graduating in 1940. In his three varsity seasons, he scored a total of 1,189 points. In 1953, "Riv" returned to Marshall and took over for Henderson. He held the job until 1963. In his final game as coach, Marshall defeated St. Francis, giving Rivlin his 100th victory. His teams lost 88 games.

Estelle M. Belanger, a reporter and editor for the Huntington newspapers for more than 50 years, was originally hired in 1942, when many male journalists were in the military. By war's end, "Bill," as she was known to friends and readers alike, had proved herself more than capable of handling any assignment that came her way. Best known for her coverage of the arts, she retired in 1977 but continued to write occasional pieces for *The Herald-Dispatch*. She died in 2000.

In 1936, as Marshall was planning its 100th anniversary, Curtis Baxter, a professor in the English Department, convinced the administration to schedule a year-long series of cultural attractions as part of the celebration. The first event: an appearance by explorer Richard E. Byrd. From that modest beginning grew the Marshall Artists Series, which continues to bring world-class entertainment to the campus and community each year. Baxter, shown here with Carol Channing, managed the program for 36 years.